SECRET RICHMOND & SWALEDALE

Andrew Graham Stables

AMBERLEY

About the Author

Andrew Graham Stables was born in Barnard Castle and studied at Teesdale School. He was involved in the recent refurbishment of Richmond School as a project planner for a building services company. His previous books include *Secret Penrith* (2016), *Secret Kendal* (2017) and *Secret Barnard Castle & Teesdale* (2018).

First published 2018

Amberley Publishing
The Hill, Stroud
Gloucestershire, GL5 4EP

www.amberley-books.com

Copyright © Andrew Graham Stables, 2018

The right of Andrew Graham Stables to be identified as the Author of this work has been asserted in accordance with the Copyrights, Designs and Patents Act 1988.

ISBN 978 1 4456 8391 1 (print)
ISBN 978 1 4456 8392 8 (ebook)

British Library Cataloguing in Publication Data.
A catalogue record for this book is available from the British Library.

Origination by Amberley Publishing.
Printed in Great Britain.

Contents

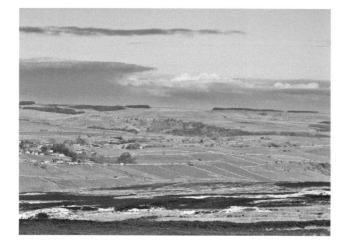

View of field patterns into Swaledale.

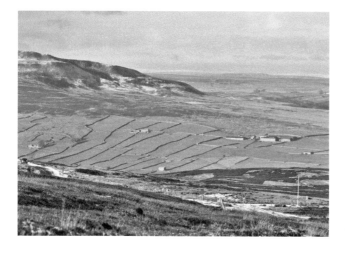

View into Swaledale.

Visible defences of Stanwick Iron Age Fortifications.

Introduction

Richmond is an historic market town based around a Norman castle sat on an outcrop of rock high above the River Swale, but the surrounding area is also steeped in a much earlier history and the valley of the River Swale has been an important home to our prehistoric ancestors too. Named after the river, Swaledale reveals evidence of occupation from the Mesolithic Age (8000–6000 BC) and the Neolithic period (2500–1800 BC) with the discovery of flint tools as well as arrowheads. There are also several sites from the Bronze and Iron Age including a huge settlement attributed to the Brigantes tribe at Stanwick, just north of the A66 road.

> DID YOU KNOW?
> A survey in 1988 recorded over 8,000 km (5,000 miles) of drystone walling in the Yorkshire Dales.

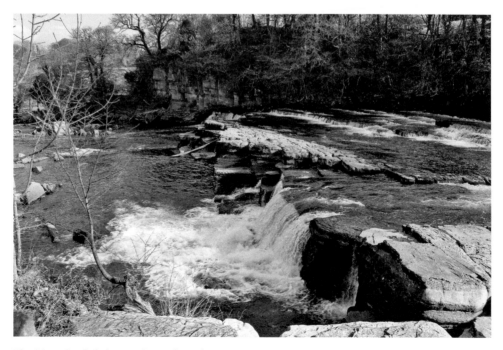

The River Swale below Richmond Castle.

Saxon history is also prevalent in the area and is perfectly expressed in a *Gazetteer* from 1823:

> The Swale was in high estimation among our Saxon ancestors. By whom it was styled the Jordan of England owing to Paulinus, the Roman missionary and the first Archbishop of York, having soon after the introduction of Christianity, baptized in its streams in one day, ten thousand men exclusive of women and children.

Though Swaledale has the look of an idyllic rural environment, the land is scarred with redundant buildings, spoil heaps and water hushes from the mining industry over the centuries. The search for minerals like tin, copper and coal has been carried out since Roman times but lead has always been the main focus of industry in the area.

This book will look at some known histories of Richmond and Swaledale but will also explore lesser-known facts and people who have influenced this beautiful part of Yorkshire. Many have left an indelible mark on the area – and in some cases the world – simply by their force of personality or the buildings they built and because of the events involving them. The book will also reflect upon plague, treason and education as well as the conflicts that have shaped the land.

DID YOU KNOW?
Some of the drystone walls have initials carved into a stone near the base to indicate who is or was responsible for that section.

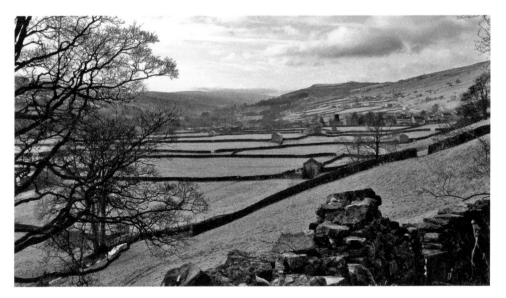

Upper Swaledale.

1. An Ancient Dale

Iron Age Forts

Swaledale has evidence of occupation from the Mesolithic Age (8000–6000 BC) and the Neolithic period (2500–1800 BC) in the form of flint tools as well as arrowheads. However, several sites show evidence of Bronze and Iron Age settlements including Whitecliffe Scar, Harkerside How Hill (Low Whita) and earthworks near Grinton. On Harkerside Moor there is evidence of old field patterns, house platforms and a stone circle, which would suggest a substantial population. This is overshadowed by the Iron Age settlement attributed to the Brigantes tribe at Stanwick St John, just north of the A66, and to put this site in perspective, the well-known Maiden Castle in Dorset is 19 hectares (47 acres), whereas Stanwick Iron Age Fortifications cover an area of over 300 hectares (750 acres). This is comparable to the size of Richmond now, and the true scale of this complex is awe-inspiring. At the time of Boudicca this site was ruled by another queen called Cartimandua, who at first collaborated with the Roman invader, but following a dramatic fall out with her husband, led the tribe to open defiance and rebellion against the Romans. Cartimandua is an interesting character and was obviously a woman of great power in the north of the country. Her story has only been told from the Roman histories but would not be out of place in a modern-day soap opera. She was married to Venutius, who was possibly a member of the Carvetti tribe from Cumbria, but divorced him and replaced him with his armour-bearer. Venutius, obviously upset with this state of affairs and her conciliatory attitude towards the Romans, would not accept the situation and raised support from other disaffected nobles to attack his ex-wife. Even with Roman assistance, Cartimandua could not put down the revolt and in AD 69 Venutius took advantage of a period of Roman political instability following the death of Nero and became leader of the Brigantes. Venutius was now king but within ten years the Romans would defeat him and subjugate the region to push the boundaries of the empire ever north.

Many artefacts have been found during the excavations including an Iron Age sword, a skull from a severed head with wounds inflicted by a sharp weapon and a metal hoard, some of which is displayed in the British Museum. During the excavations in the 1980s the Durham University team found a male burial, near a rampart, where a horse's head had been placed upon the body. Some estimates believe the occupation levels of the Stanwick Fortifications could have been as high as 85,000 people and the excavations tend to support this number. It may have been the base for other tribes forced out of their homelands further south and may have been swelled by refugees.

There is another hill fort called How Hill, which is a prominent isolated hill at the head of Swaledale near the village of Downholme. The site contains the remains of a bank and ditched univallate hill fort, which is partly covered by medieval strip ploughing. Further settlement has been excavated under Whitcliffe Scar, which is believed to have been occupied up to AD 600.

DID YOU KNOW?
The term 'how' refers to a small hill or a man-made mound or barrow possibly from the Norse 'haugr'.

During the Roman period a great fort was established at Catterick, within easy reach of the lead mines of Swaledale. It is thought that the Brigantes may have worked as slaves in the first mines on the moors to the north of the dale. There is no visible evidence of Roman roads, villas or forts within the dale.

Gilling West

To the north of Richmond is the village of Gilling West, a place linked to the site of an early monastic complex. Yorkshire was once referred to as the kingdom of Deira and at times joined its northern neighbour of Bernicia to become Northumbria. Following the Saxon invasions of the fifth and sixth centuries, Christianity was lost to the pagans until rekindled when Edwin, king of Northumbria, married the Christian Ethelburga of Kent,

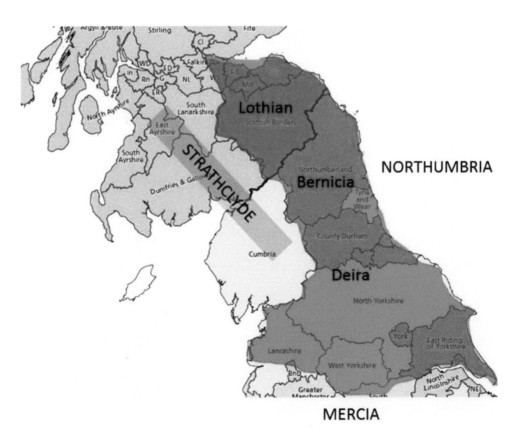

Northumbria *c.* AD 600.

and one of Augustine's fellow missionaries, Paulinus, was consecrated bishop of York. This was in AD 625, only twenty-eight years after Augustine had established the English church at Canterbury.

In 633, Edwin was defeated by Penda and Cadwallon at the Battle of Hatfield near Doncaster and Bishop Paulinus escaped to Kent, taking with him Edwin's widow and her daughter. Within a couple of years, Oswald, Edwin's nephew, routed the pagan Mercians at Heavenfield, near Hexham, and Northumbria was again brought under Christian rule. Oswald was killed around 642 and his realm was again divided. Oswi, his younger brother, succeeded in Bernicia, while Deira recognised Oswin as their king. Soon Oswi laid claim to the whole of Northumbria, and conflict threatened but Oswin, realising the strength of Oswi's forces, dismissed his men 'at the place which is called Wilfaresdun, that is, Wilfar's Hill, which is almost ten miles distant from the village called Cataract, towards the north-west'. He concealed himself in the house of a supposed friend, but was betrayed and then murdered on Oswi's orders. Bede states this occurred in 651, 'at a place called Ingethlingum, where afterwards a monastery was built'. Oswi, through either guilt or entreaty, granted lands for the upkeep of a monastery on the site of Oswin's death.

Ingethlingum is generally regarded as being Gilling and Bede mentions the first abbot of the monastery at Ingethlingum as Trumhere. It is thought Gilling monastery would be built sometime after 651, and in 659 Trumhere was followed by Cynefrith, who only lasted a year before Tunberht succeeded him. These are the only three abbots recorded, and though the building itself may have stood for another 200 years, it is believed to have been destroyed during the Danish invasions of 866–67.

DID YOU KNOW?
A last vestige of the Anglo-Saxon custom of 'infangtheof and outfangtheof' allowing landowners to enforce summary justice on thieves was still inforce in Richmond in the early Norman period.

Today there is no trace of the monastery, though there are fragments of Anglo-Saxon sculptured crosses within the church porch, which point to Christian worship in Gilling in the ninth and tenth centuries.

From the ninth century, Gilling (Ghellinges) was the chief seat of the Saxon Edwin, Earl of Mercia, and it is understood that his stronghold was on Castle Hill, near to where Low Scales Farm now stands. However, following the Norman Conquest, Edwin's lands were given to the Norman Lord Alan Rufus, who decided to build his mighty castle several miles away in Richmond, leading to the demise of Gilling's former high status in the area.

Many of the cottages and houses date back to the sixteenth century and at the north end of the village the green was formerly a walled pinfold for the enclosure of stray animals. There are the remains of a former water point (dating to around 1897) with a cast-iron animal mask, which is attached to a wall and may have formed part of the now incomplete enclosure.

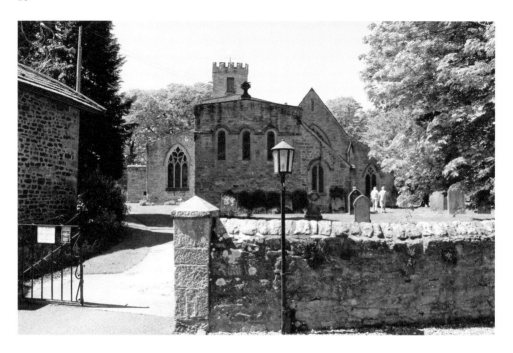

Above: St Agatha's Church, Gilling West.

Left: St Agatha's Tower, Gilling West.

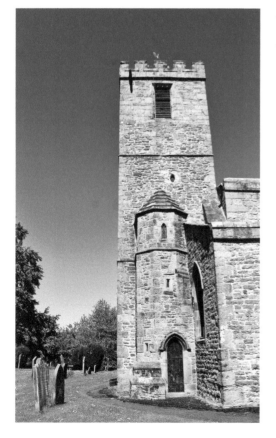

The Angel, Gilling West.

At the north end of the High Street is a large house that at one time was the old parsonage, before being replaced in 1807 by a new vicarage next to the church when William Wharton (in preparation for his marriage in 1808) had a complete street demolished to provide a suitable site (now Gilling Hall).

The Domesday Book of 1086 mentions a church in Gilling and it is believed that the present church is built on the site of the monastery destroyed by the Danes. St Agatha's Church is thought to have been restored or rebuilt towards the end of the eleventh century with modifications in the fourteenth century, and then totally refurbished in 1845, as many churches were in the Victorian period.

Edwin and the Events of 1066

Edwin, Earl of Mercia, had an important role to play in the history of these isles when at Easter, in 1066, King Harold married the sister of Earl Edwin and Earl Morcar, thereby cementing the alliance of the three great earldoms of Wessex, Mercia and Northumbria. In the summer William of Normandy was gathering his fleet in preparation to invade England to try and take the crown from Harold. At more or less the same time another claimant to the throne, King Harald Hardrada, sets sail with his fleet from Norway.

In September, William attempts to cross the Channel but was driven back into port by the winds, and Hardrada visited the Orkney and Shetland Isles to increase his fleet from 200 to 300 longships. The Norse fleet attacks coastal settlements at Tynemouth, Scarborough and Holderness before sailing down the Humber and Ouse rivers to Ricall. At Fulford, near York, Hardrada defeats the army of the northern earls including Edwin and Morcar. After this defeat, King Harold gathers an army, abandons the south coast and the threat of a Norman invasion to set out for York. Marching at a great pace, they rested near Tadcaster to reinvigorate and also maintain the element of surprise.

On the 25 September King Harold defeats and kills Hardrada as well as his ally Tostig at Stamford Bridge, but two days later William's fleet sets sail and arrives the next day on the south coast. With this news, Harold sets off immediately for London, arriving on the 6 October, and within the week leaves London to confront William's army. They engage in battle on the 14 October and at the Battle of Hastings the Norman invaders defeat Harold, who is slain along with many of the Saxon nobility.

DID YOU KNOW?
During the recent A1 upgrade near Catterick, archaeologists unearthed more than 177,000 artefacts from a Roman settlement dating back to AD 60.

Edwin and Morcar were absent from the battle but supported Edgar, the last of the Wessex line, but Edgar was only young and struggled against the invading Normans. He soon submitted to William, who now tightened his grip on the country. In 1068, Edwin and Morcar attempted to raise a rebellion in Mercia but fled as William moved against them. They were pardoned by William but in 1071 they fled to Scotland, believing they were about to be imprisoned, but were betrayed by their own men and killed. It is thought the Honour of Richmond was established around this time.

Scots Dyke

Scots Dyke is a linear earthwork extending for 14 km from the River Swale to the River Tees in North Yorkshire. Significant sections remain visible as upstanding earthworks and indicate that the dyke system had an earthen rampart flanked on the eastern side by a ditch. While it has not been preserved as an upstanding monument, the dyke is visible as a cropmark on aerial photographs and often survives as a low bank beneath present field boundaries. It was constructed in the post-Roman period and encloses an area in the eastern foothills of the Pennines between the two rivers. This area contained wealthy arable and pastoral land as well as some of the mineral resources of the northern Pennines. Linear earthworks were used to divide territory for military, social, economic and political purposes, often using natural features such as rivers and watersheds to define an area. Scots Dyke was built to consolidate territory, probably in response to the ever-changing political events in the sixth and seventh centuries.

The Round Howe

The whole of Swaledale is full of geological features including Drumlins, Erratics and Moraines, but Round Howe, close to Richmond, is a very remarkable natural curiosity. The hill (or howe) is conical in shape and rises up in the middle of an immense basin of rock. It is situated on the south side of the Swale, opposite Whitcliffe Mills, and is part of a much loved local walk.

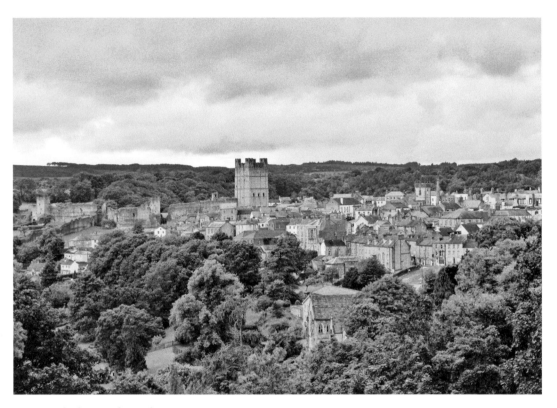

Overlooking Richmond.

2. The Honour of Richmond

It is believed the Honour of Richmond (Honour meaning 'land comprising of manors held by a Baron') was established by the Norman invaders between 1069 and 1071, much of which originally belonged to Edwin, Earl of Mercia.

A list of the holders of the honour of Richmond:

Alan Rufus, Count of Brittany (d. 1093)
Alan the Black (d. 1098)
Stephen, Count of Tréguier (d. 1136)
Alan, 1st Earl of Richmond (d. 1146)
Conan IV, Duke of Brittany (d. 1171)
His heir was a daughter Constance (d. 1201), who was a ward of Henry II pending the marriage to his son Geoffrey.
Geoffrey II, Duke of Brittany (d. 1186), first husband of Constance
Ranulph, Earl of Chester (d. 1232), second husband of Constance, whom she married in 1188 and she divorced in 1199.
Guy of Thouars, third husband of Constance, who forfeited to King John in 1203 after taking up arms with the French.
Alix, Duchess of Brittany (d. 1221).
Peter I, Duke of Brittany, the husband of Alix of Thouars
Peter II, Count of Savoy, also known as Earl of Richmond
John II, Duke of Brittany (d. 1305)
John of Brittany, Earl of Richmond (d. 1334)
John III, Duke of Brittany (d. 1341)
John de Montfort, Earl of Richmond (d. 1345)
John of Gaunt
John IV, Duke of Brittany
Ralph de Neville, 1st Earl of Westmorland
John of Lancaster, son of Henry IV
The Crown (1435–50)
Ralph Neville, Earl of Westmoreland
Edmund Tudor (d. 1456), father of Henry Tudor (later Henry VII)
Henry Tudor forfeited to Edward IV during the War of the Roses, with George Plantagenet, 1st Duke of Clarence, granted the honour and castle in 1462
Richard, Duke of Gloucester, from 1477, and retained when he became Richard III
Henry Tudor (later Henry VII) took the honour following the Battle of Bosworth Field in 1485 against Richard III, and the honour was merged with the Crown

The honour was held by members of Tudor and Stuart dynasties, as part of the Crown including the illegitimate child of Henry VIII, Henry FitzRoy, who became Duke of Richmond and Somerset in 1525. When the duke died without issue in 1536, his titles became extinct

Charles Lennox was the illegitimate son of Charles II and he was granted the title in 1675.

DID YOU KNOW?
Richmond was called Hindrelac in the Domesday Book, probably the Old English name for the town.

The Lennox family still hold the title. Charles Gordon-Lennox is the 11th Duke of Richmond (also 11th Duke of Lennox, 11th Duke of Aubigny, 6th Duke of Gordon and Deputy Lieutenant) and owner of the Goodwood estate in West Sussex. He is president of the British Automobile Racing Club, patron of the TT Riders Association and an honorary member of the British Racing Drivers Club, the Guild of Motoring Writers and the 500 Owners Club.

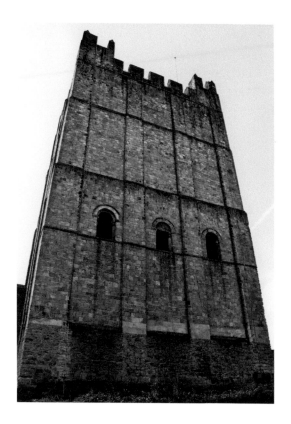

Richmond Keep.

For his service at the time of the Norman Conquest and in an effort to finally subdue the north of the country, William the Conqueror gave an extensive region in Yorkshire to his kinsman Alan Rufus of Brittany, most of which had belonged to the Anglo-Saxon and rebellious Edwin, Earl of Mercia. Although the exact date of the grant is uncertain, tradition says the gift was made at the siege of York and would most likely be around 1069. It is known that at the time of the Domesday Book, Count Alan was in possession of the district that would become known as Richmondshire. The liberty, honour or earldom of Richmond was described as 'the land of Count Alan' and the divided under the two chief manors of Gilling and Catterick. The actual first mention of the 'honour of Richmond' does not occur until 1203, and in the early part of the thriteenth century it was also often called the honour of Britanny.

A 'Court of Richmond' is first mentioned at the start of the thirteenth century and a court leet, denoting a territorial and a jurisdictional area run by the local lord, in 1341. The court leet was held every three weeks and was worth 20s per year, but no more because of the poverty of the residents.

Richmond Castle

Richmond Castle is one of the earliest stone-built castles in the country and no other in England can boast so much surviving eleventh-century architecture. Count Alan Rufus (the Red) was granted vast lands in the north following his service to William the Conqueror at the Battle of Hastings. Building work is believed to have started soon after 1071 to suppress the recently dispossessed Anglo-Saxon nobility and establish Norman power in the north. The castle is actually mentioned in the Domesday Book as a 'castlery', meaning an 'estate organised to sustain a castle'. The earliest sections of the castle include some of the curtain wall, the great archway in the ground floor of the keep and Scolland's Hall.

Alan Rufus died in 1093 and the estates passed to his younger brothers, Alan Niger and then Stephen, but by 1136 it was held by Stephen's son, another Alan, who was the first to be referred to as the Earl of Richmond. Earl Alan married the heiress of the Duke of Brittany, but when Alan died in 1146 before the dukedom became his, it was his son, Conan, who succeeded to this title in the 1164. This put Conan at the head of the two massive domains of Brittany and Richmond.

DID YOU KNOW?
Geoffrey, Earl of Richmond, died in Paris in 1186 competing in a tournament where he was unhorsed and trampled to death. Though there are questions about this official version of events, it is also recorded that he was suffering from abdominal pain at the time.

A castle brings fairs and markets, and so the town soon began to prosper. As early as 1145 the town was made a borough, which conferred some privileges to the burgesses in return for rents. Conan, as the overlord of estates in Brittany and a flourishing English

town, is credited with building the keep as a statement of his power. He also betrothed his daughter to Henry II's fourth son, Geoffrey, with the duchy of Brittany as part of the deal, but Conan died in 1171 when his daughter was only nine years old. Henry II took control of Richmond Castle until the marriage in 1181, when Geoffrey became Duke of Brittany. During this period Henry is recorded as making repairs to the castle and may have actually completed the keep. The south wall of the keep is built on the earlier curtain wall, but its other three walls are of one date. It measures around 100 feet high and due to its slender proportions gives a great impression of loftiness. The castle also held William, King of Scotland, after he had been captured at Alnwick in 1174 following his sortie via the Eden Valley and over the Stainmore Pass.

It is possible the castle was the subject of a siege in 1215 during the revolt against King John and in 1265 when Simon de Montfort rebelled against Henry III but there are no definitive records to confirm this. One story is that King John visited Richmond and during the rebellion against him he ordered the Earl of Chester to demolish the castle of Richmond if he could not hold it. Clearly this destruction was never carried out.

Throughout the thirteenth and fourteenth centuries the castle was subject to a long-running international dynastic dispute. The honour of Richmond was still held by the dukes of Brittany, but the price of enjoying it was obedience to the king of England, while holding their French lands required fealty to the king of France. With the monarchs of the two countries regularly in conflict, allegiance was always divided and difficult to deal with, so the honour and castle were usually held by either the English Crown or a royal favourite. This difficulty continued until 1372, when the castle and honour were finally surrendered to the Crown. Those endowed with the Honour of Richmond over the following years included Ralph Nevill, Earl of Westmorland, Edmund Tudor (whose son became Henry VII), George, Duke of Clarence (brother of Edward IV), and later his other brother, Richard, Duke of Gloucester (Richard III).

The result of the ownership dispute and royal connections was the lack of upkeep or alterations during this period. Some work was carried out in 1250 by Henry III and by Edward I after 1294. Though it is unclear exactly what work was undertaken by these two notable kings and the castle proceeded to lapse into a state of disrepair to eventually became a ruin. In 1535, Leland, described it as a 'mere ruine' and in a survey in 1538, described 'the port lodge, the inner gatehouse, the sware house, the mantill wall and five turrets, the great dongeon, two wells, the hall, pantry, buttery, kitchen and other offices, the privy chamber, a little tower for draughtes, the great chamber, a chapel next it, and a chapel in the castle garth with the masonry and timber much decayed.'

DID YOU KNOW?
John II, Duke of Britany and Lord of Richmond, died in 1305 when a wall fell on him as he was leading the horse of the new pope. The wall was apparently overburdened with spectators.

In 1675 Charles II gave it to his illegitimate son Charles Lennox, whom he also created Duke of Richmond, and some essential repairs to the keep were carried out in the 1760s. However, it was the rise in the romantic period of art, which peaked in the early 1800s, that led to something of a revival. Works by artists like J. M. W. Turner encouraged the idea of the romantic ruin and the town became a fashionable tourist attraction. Some of this was due to the Napoleonic Wars prohibiting the upper class taking a 'Grand Tour' of Europe and alternative locations were sought to take the air or to take the mineral waters.

The Victorian period saw a return of use for the castle and, at the time of the Crimea War (1853–56), in 1854 the castle was leased out to the North York Militia. Within the year a barrack block was built next to the west curtain wall and the keep modified with the addition of a reserve armoury building next to it. By 1908 the castle became the headquarters of the Northern Territorial Army and Robert Baden-Powell, who went on to found the Boy Scouts, commanded for a short time. In 1910, the army handed over the historic sections of the castle to the Ministry of Works, although they retained control of the barracks and armoury. The Victorian barracks were demolished in 1931 but the armoury building was retained.

During the First World War the castle housed conscientious objectors, men who had asked for exemption from military service because it was against their beliefs. Many were Methodists, Quakers and Jehovah's Witnesses and even socialists. Where some men from these faiths would become medics or orderlies during the fighting, some refused to

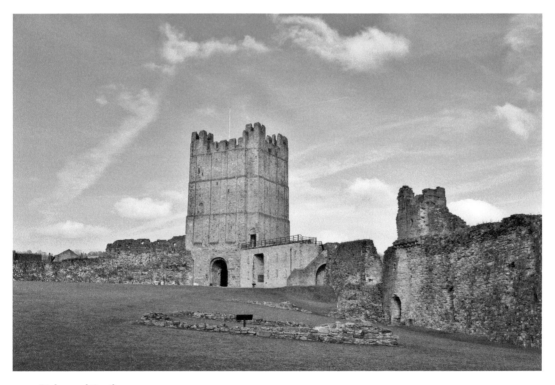

Richmond Castle.

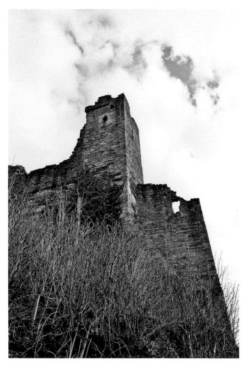

Above left: Tower above Castle Walk.

Above right: Castle Walk.

undertake any work involving the war effort. These men were held in cells at the castle and became known as the 'Richmond Sixteen'. They were sent to France in May 1916 and were put on trial for refusing to obey orders. They were sentenced to death, but the sentence was eventually commuted to ten years' hard labour.

The castle and especially its keep have been a symbol of Richmond for nearly 1,000 years and latterly as a symbol of hope even during the Second World War when it was used to watch for enemy activity in the area and the keep was used as an air-raid shelter.

Town Walls

In the late thirteenth and early fourteenth centuries Scottish raids into Yorkshire were frequent and affecting revenue from the land. They also threatened to inflict 'fier and spoile' on the town, so John, Duke of Brittany, obtained a royal licence to build a wall around the town of Richmond. The cost would be raised by a levy, for the term of five years, upon goods sold in the market. The wall no longer stands but evidence of its position and size can be ascertained by the remaining gates and the town's current layout. The wall connected to the castle and encompassed the market area, with one gate or bar located at the top of Cornforth Hill and a postern gate is located in Friars' Wynd. The French Gate Bar, Finkle Street Bar, was taken down in 1773 to widen the town's entry points as part of the expansion of roadways known as turnpikes.

Cornforth Hill Bar exit.

Cornforth Hill Bar entrance.

Cornforth Hill Bar and its proximity to the castle.

Friars Wynd Postern Gate.

Ravensworth Castle

To the north-west of Richmond lies an extremely ruinous castle – Ravensworth. There seems to be no record of the original foundation of the castle but it was the home of the Fitzhugh family until the sixteenth century. The Domesday Book lists the manor of Ravensworth as having been held prior to the Conquest by Torfin, who also owned other lands in the area. He may have been followed by illegitimate relatives of Alan Rufus (Honour of Richmond), who took over the lordship after the conquest. The family were of considerable importance and founded the Jervaulx Abbey (between Middleham and Masham, North Yorkshire) where many of the Fitzhugh's are buried. In 1201 a visit by King John is recorded, though evidence suggests that the remaining castle was built later and an outer wall built around the park in 1391. The last Fitzhugh, George, the eighth baron, died without issue in 1512 and the estate was divided between members of the family, but when William Parr, the Earl of Essex, died without issue in 1571 his estates passed to the Crown.

The antiquary John Leland visited Ravensworth around the mid-sixteenth century and noted 'the castle, excepting two or three towers, and a faire stable, with a conduct coming to the hall side, had no thing memorable'. However, within fifty years, when the site was held by the Crown, the castle was certainly in a state of advanced decay and documents allude to the removal of cartloads of stones being taken away for other building works.

DID YOU KNOW?
In 1322 John, Earl of Richmond, was captured by the Scots at the Battle of Old Byland and only released two years later after a large ransom had been paid.

The most unusual feature of the castle is that unusually it is built on low-lying land and surrounded by marshland. This is contrary to the normal requirements of a strong defensive position, usually on a high rocky outcrop with a fresh water supply. It may be the castle was more of a fortified hunting home and designed to entertain other important dignitaries.

Unfortunately, the castle is on private land and declared unsafe, and therefore not open to the public.

Hornby Castle

Hornby Castle sits south-west of Catterick village and is a Grade I-listed fortified manor house originating from the fourteenth century, but remodelled in the fifteenth and much altered in the eighteenth century. In 1930 the estate was broken up and most of the house was demolished.

Towards the end of the fourteenth century the castle was owned by the St Quintin family until heiress Margaret St Quintin married John Conyers. It appears Margaret was the heir to Thomas St Quentin's estate of Hornby between the ages of eight and ten in 1391:

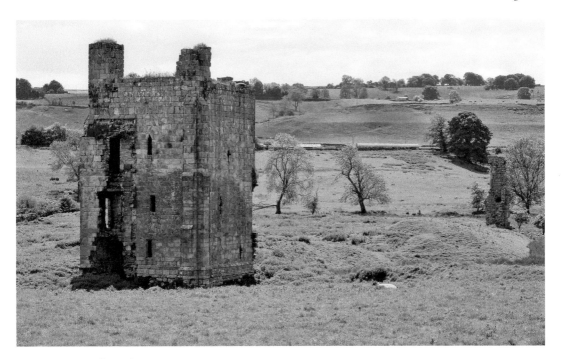

Ravensworth Castle.

an indenture was sealed between Richard Scrope and John Conyers whereby Richard has sold to John the wardship of the person and lands of Margaret, cousin and heir to Thomas St Quentin, knight, of Hornby, in Richmondshire, which pertains to him because of the minority of Margaret. John has paid 200 marks to Richard for the wardship.

William Conyers, 1st Baron Conyers, almost entirely rebuilt the castle while retaining the fourteenth-century St Quintin Tower, and the Conyers family retained ownership until 1557. It was then when the estate passed through marriage to the Darcy family, who were created the Earls of Holderness in 1682.

The house was again modified in the 1760s for the 4th Earl of Holderness by the prolific architect John Carr from York. His daughter married Francis Osborne, Marquess of Carmarthen, who later became the 5th Duke of Leeds, and he assembled a collection of early eighteenth-century furniture. In 1811 Hornby became the main seat of the Dukes of Leeds until George Osborne, 9th Duke of Leeds.

As with many stately homes between the wars, much of the house was broken up and demolished and the remaining property was bought in 1936 by Major-General Walter E. Clutterbuck, who served with distinction in the First and Second World Wars. Hornby was passed down to the family, who restored the parkland and even introduced a small herd of bison. The hall is a private residence and is not open to the public, but the gardens are regularly open to visitors.

A sixteenth-century main doorway from the original house has been preserved in the Burrell Collection, Glasgow.

3. A Military Town

The Green Howards

The Green Howards Museum is based in the former Trinity Church situated in the marketplace and has been since 1973. The museum tells the 300-year-old story of this illustrious regiment with its collection of military artefacts and donated personal items. Indeed, my father was taken from an orphanage at the age of sixteen to serve as a band boy with the regiment in 1946 until sometime in 1948.

The regiment was originally raised by Colonel Francis Luttrell in 1688 and saw action in Flanders during the Nine Years' War and later during the War of the Spanish Succession and the War of the Austrian Succession. They were also involved in the Seven Years' War in the 1760s but soon after all regiments of foot without a special designation were given a county title 'to cultivate a connection with the County', which was seen as a recruiting incentive, and the regiment was redesignated the 19th (1st North Riding of Yorkshire) Regiment.

From 1744 the regiment were known as the Green Howards after their colonel Hon. Sir Charles Howard. However, the 3rd Regiment of Foot was commanded by Colonel Thomas Howard, and it was the colours of their uniform that was used to distinguish between them. One became Howards Buffs and the other the Green Howards.

The regiment has served throughout the world including Ceylon (now Sri Lanka), the Crimea and the Indian Mutiny, and distinguished service in the Boer War, the First World War and the Second World War. Very early in the First World War, at the 1st Battle of Ypres in October 1914, this professional force sustained heavy casualties in a new industrialised kind of warfare. A visit to the medal room in the Green Howards Museum will impress upon anyone the great honours earned by the regiment.

The regiment has earned many of the highest honours bestowed by this country including the Victoria Cross, and one of my favourite recipients is Stanley Elton Hollis, who, unbelievably, was the only man to receive a VC on D-Day in 1944. Born in Middlesbrough, he was uniquely recommended twice for the VC in actions at Gold Beach, Normandy, where his courage saved numerous lives and he was instrumental in significant advances during the day. Hollis realised two hidden German pillboxes had been by-passed and without hesitating he rushed forward to the first pillbox, pushing his Sten gun through the slit, climbing on top and throwing in a hand grenade. At the second pillbox, he attacked and took twenty-five prisoners. A couple of his own troops were trapped in a house so he rushed out firing his Bren gun with the enemy firing at him, which enabled the trapped men to get out and away from the house. He continued fighting until September 1944 when he was wounded for the fifth time during the war and evacuated to England. He later found out, after the war, he had some shards from bullets still lodged in the bones of his feet.

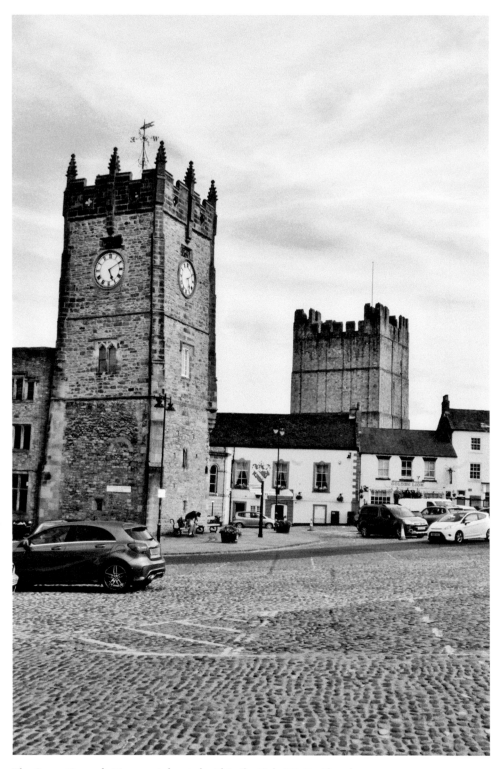

The Green Howards Museum is located within the Holy Trinity Church.

The old barracks on Gallowgate.

Catterick Garrison

Catterick Garrison is the principle military base in the north of England and is currently expected to expand to accommodate 25,000 troops. The original notion of establishing a military camp at Catterick stretches back to before the First World War when it was recommended in 1908 by Lieutenant-General Sir Robert Baden-Powell, the founder of the Boy Scouts movement. He was based at Richmond Castle for a time but felt the grounds restricted any further expansion of the force. The first site for the camp was actually chosen by Major-General Sir George Scott-Moncrieff, who was an engineer and director of fortifications and works. The order to construct the camp was issued in August 1914, exacerbated by the start of the First World War, with the site being first occupied in 1915 and the new camp's railway line opened in the same year. Initially known as Richmond Camp, it was renamed Catterick Camp to avoid confusion with the Richmond in London.

At the same time, Catterick airfield was also opened, operated initially by the Royal Flying Corps for pilot training and home defence duties. In these early days of flight the airfield supported only a few aircraft, but as the war and technology progressed, further squadrons were formed. During 1916, a flight from 76 Squadron took up residence and stayed at Catterick with the responsibility for the defence of Leeds and Sheffield.

Catterick opened as a full aerodrome on 1 December 1917 and in April 1918, following the creation of the Royal Air Force, the airfield became known as RAF Catterick.

Designed to accommodate two divisions of troops, the maximum number at the camp was around 42,000 during the First World War, but towards the end of hostilities the camp was transformed from being just a training centre to include a prisoner of war camp. At the end of the war, the camp became a demobilisation centre, a training centre, and eventually a dump for artillery pieces as well as transport vehicles.

In the 1920s, Catterick became a permanent military training centre, with the construction of new buildings and the purchase of land for training purposes. In 1924, the Signal Training Centre moved to the base from Maresfield in Sussex and the Royal Signals became an integral part of the garrison. Further expansion was sanctioned in the mid-1930s including the 'Sandhurst' Blocks and Garrison Headquarters. During the Second World War the garrison was expanded further to accommodate a division-sized administrative headquarters commanded by a major-general and once again a prisoner of war camp.

Post-Second World War the base continued as a training centre, changing designation over the years but essentially remaining a training headquarters in the north. In 1996, 19 Mechanized Brigade was assigned to headquarter here until it was split into two separate headquarters of 19 Mechanized Brigade and Catterick Garrison. In January 2005 Headquarters 19 Mechanized Brigade became Headquarters 19 Light Brigade until 2008 when 19 Light Brigade moved to Northern Ireland and were replaced by 4 Mechanized Brigade from Germany. The garrison has continued to develop over the years as military thinking changed and the army reorganises due to cuts and the various demands placed upon it. Most recently the base is to be extended to cater for 25,000 troops and will ensure it is still the largest conurbation in the area.

4. Buildings

Ellerton Abbey

Ellerton Priory is a small ruined nunnery sat on the southern bank of the River Swale, just off the road heading west to Grinton and almost opposite another nunnery, Marrick Priory, on the northern bank. It is believed Ellerton was founded around 1200 by the local Eaglescliffe family but was one of the poorest and smallest in the whole of Yorkshire. The remaining tower and church were modified in the nineteenth century to create the ideal 'romantic' ruin much loved in the Victorian period.

Leland described the small Cistercian nunnery dedicated to St Mary as 'a priori of white clotid nunnes, stonding in a valle, a mile beneath marik priori'.

According to a recent archaeological survey the ruined church stands at the centre of other walls and buildings now only visible as earthworks. The cloisters were located to the south with walled courtyards to the north and other ranges suggesting a kitchen or refectory (or indeed both). Other features include an isolated building, possibly a guest house or infirmary, and gardens with possible a fish pond features.

The tower, though originally constructed in the thirteenth century, has been modified and added to over the centuries. New windows were added in the fifteenth century along with the angled buttresses and stair tower, but further alterations in the nineteenth century raised the tower by up to 1.5 metres in height. It is thought these changes were carried out by the Erle-Drax family, who also built the Ellerton Abbey (house) in the grounds around 1830.

The site is of major significance due to the lack of development, disturbance to the land and the length of single ownership, though oddly no evidence has been found so far for a burial ground, which would be expected on a site like this (clearly evident at Marrick for example).

Following the Reformation, the priory was surrendered on 18 August 1536 by Joan Harkey, and it was subsequently dissolved in 1537. Joan was granted a small pension of £3 but she died in poverty in Richmond.

Hospital of St Nicholas

The Hospital of St Nicholas is mentioned in the Pipe Roll of 1172, where Ralph de Glanville, Chief Justice of England, gave to the sick of the hospital of Richmond 'five seams of bread corn'. However, exactly when it was founded and by whom has not been ascertained, though clearly it is before 1172. Further records from 1334 mention a Nicholas Kirkby, who gave some lands in Richmond and Skeeby for the upkeep of the hospital. He also endowed a pension of £3 to the chaplain, who was to say mass daily in the chapel of St Edmund, as well as in the chapel of St Nicholas.

Ellerton Priory.

However, in 1448, the hospital was in a poor state and the income from the lands was not enough to maintain them. It was a William Ayscough, from near Bedale, who repaired the buildings and founded in the chapel of the hospital, a chantry for one priest to say mass daily. During the Dissolution of the Monasteries, the hospital was surrendered to the king by Richard Baldwin, the last master, in 1535. The buildings remained in the possession of the Crown, and though resurrected by Queen Mary around 1553, it was granted away by Queen Elizabeth in 1585 into private hands. Sometime after this the building was modernised with some of the original fabric still incorporated.

DID YOU KNOW?
In 1724 a huge Roman hoard was found in the Castle Bank, amounting to a total of 620 silver Roman coins and spoons.

After passing through several hands, the estate came into the possession of the Norton family in 1646, followed by the marriage of an heiress to Sir John Yorke, who sold it to the Blackburnes. In 1813, the Revd Francis Blackburne sold the property to the Earl of Zetland. In mid-1800 the buildings were further modified and during these works a large

quantity of human bones were found, as well as a small chalice and a stone coffin. The house continued to be occupied privately and as recently as 2017 was up for sale. On selected Sundays in spring and summer, the gardens are open to the public.

This building, built sometime in the medieval period but largely rebuilt in Tudor times, and further modified during Victoria's reign, claims to be the oldest continuously inhabited house in Richmond.

Sedbury Hall

Less than a mile from Scotch Corner is Sedbury Hall with over 300 acres of well-wooded parkland as well as an estate of farmhouses. The current hall was redesigned by the famous and prolific Georgian architect John Carr (1723–1807) around 1770, but prior to this the estate is known to have housed the racing horses of Charles II.

James D'Arcy (1617–73) was the stud master to Charles II and acquired Sedbury Park from Sir Marmaduke Wyvill. The stables were once home to such legendary horses as the Darcy Yellow Turk and the Darcy White Turk at a time when Gatherley Moor racecourse and the surrounding area were described as the 'Newmarket of the North'.

Sedbury is first mentioned in the twelfth century and seems to have been held by the de Scargill family but seems to have been divided between the families of de Barningham and the le Scrope's of Bolton over the following 300 years. The Boynton family were the custodians in the mid-1400s until the estate came to be owned by the Gascoigne family in the sixteenth century, and in around 1606, a daughter of the Gascoigne family inherited the manor with her husband Marmaduke Wyvill of Constable Burton. It was their daughter Isabel who married the Honourable James D'Arcy, and the D'Arcys were the masters of Sedbury until 1826. The building is now used as stables, office space and events hire.

Walburn Hall

Walburn Hall is located south of Downholme, off Walburn Head road, and though the current building dates to the fifteenth century, it is built on the site of an earlier medieval dwelling. The whole site includes the buried village of Walburn and extensive remains of the associated filed system.

The first records of the village of Walburn occur in 1222, though the site follows the pattern of planned settlements built by the Normans during the late eleventh and twelfth centuries and is most likely to have been set up during this period. The nearby Ellerton Priory is known to have held at least two properties in the village but as with other villages of the fourteenth century many suffered due to bad harvests, plague and raids by the Scots.

The village had two rows of buildings facing each other, built to the north and south of a wide village green, and between them was the street and a stream. The stream now follows a winding route, but surviving earthworks suggest the stream was managed during the medieval period. Some of the remaining earthworks stand up to 1.5 metres high and include rectangular buildings measuring up to 10 metres by 4 metres. Other features on the complex include formal gardens associated with the hall, the remains of a mill complete with mill race and a small kiln. There are also the remains of a major trackway extending north from a bend in the modern road, which has been identified as the medieval route to Richmond.

The remains of the manor house are to the west of Walburn Bridge adjacent to and beneath the present Walburn Hall. The earliest standing ruins date to the fifteenth century but the present hall is later fifteenth or sixteenth century in origin, with later modifications. The courtyard is walled at the south and west sides with a crenellated parapet, which was restored in the nineteenth century. Timothy Hutton of Marske in Swaledale made significant modifications to the property in the nineteenth century and the hall is said to have accommodated Mary, Queen of Scots, perhaps on her way to Bolton Castle in Wensleydale.

Topcliffe

Near the village of Topcliffe on the junction of the River Swale and Cod Beck are the remains of a manorial complex as well as a motte-and-bailey castle. The lands originally held by a Saxon lord were taken over by William de Percy, who came from the village of Percy in Normandy and was part of the trusted retinue of William I (known predominantly as the Conqueror).

Topcliffe became the Percy's principal stronghold and remained so until the family acquired Alnwick in Northumberland in 1309 from Antony Bek, Bishop of Durham. The Percy family still inhabit the castle at Alnwick as the powerful and historically influential Earls of Northumberland. They played a significant role in history as Wardens of the Marches, significant involvement in Scottish affairs and some as traitors to various kings.

DID YOU KNOW?
In the ninth century Swaledale produced half the lead mined in Yorkshire.

Plan of Topcliffe
motte-and-bailey
castle.

Richmond Racecourse

Within a few miles of each other were three major racecourses: there is Catterick, which opened in 1783, although there are references to racing around Catterick well before this date; Richmond is mentioned holding a two-day meeting in September 1669; and Gatherley (adjacent the A66 road) is referred to by the Earl of Northumberland in 1554. The whole area is sometimes referenced as the 'Newmarket of the North' and indeed George III supposedly uttered 'Oh! For a breath of Gatherley air' on his deathbed.

Located to the north-west of the Richmond, the old racecourse boasts a Georgian grandstand, which is Yorkshire's 'last surviving such structure still in its original form' and is the earliest known racecourse grandstand. Unfortunately, the structure is on the English Heritage register of buildings most in peril and could be lost due to dereliction. Thought to have been designed by John Carr, the celebrated architect in the north, it originally consisted of a five-bay arcaded ground storey fronted by a Tuscan colonnade, which supported a balcony. The upper storey repeated the arcaded styling and was topped by a balustrade, the flat roof forming a viewing platform. The top storey and the colonnade of the grandstand were demolished in 1973.

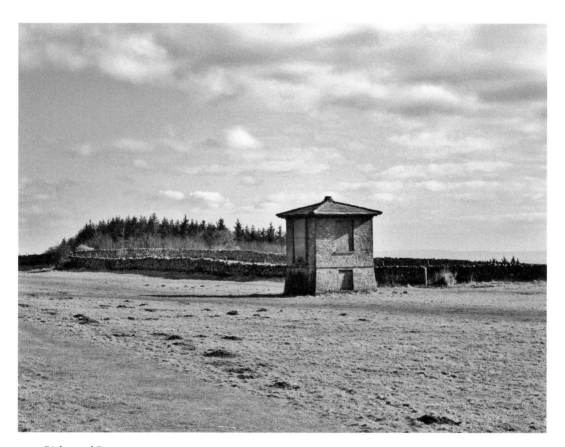

Richmond Racecourse.

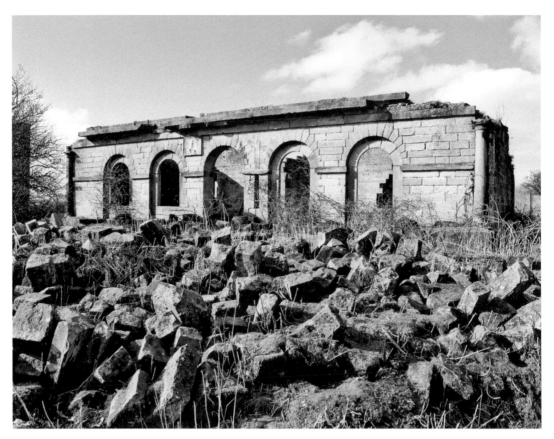

Racecourse stand.

To the south was a private stand built for Lord Zetland, which is now ruinous. There were other structures on the site as well but the course was eventually closed in the 1891 as Catterick was favoured due to its superior links to the road and rail systems. The grandstand remained in use as a social venue until after the Second World War but was derelict before being listed in 1952. The gallops are still used by nearby racing stables and are evidence of the rich racing heritage of the area.

Local patrons included the Duke of Richmond, Earl of Zetland, Duke of Leeds, Duke of Cleveland and Lord Rockingham, among others. The principal races included His Majesty's 100 Guineas, the Gold Cup, the Silver Cup, Richmond Handicap Stakes, Wright Stakes and the Town Purse. The final meeting on Thursday 6 and Friday 7 August 1891 included the Wright Stakes over 5 furlongs, which was won by Sea View, owned by Lord Zetland.

Culloden Tower

Culloden Tower is situated in the former grounds of a seventeenth-century mansion house, which was built on the north bank of the River Swale on an area of open ground just to the west side of Richmond. In 1608 the house was sold to Sir William Gascoigne

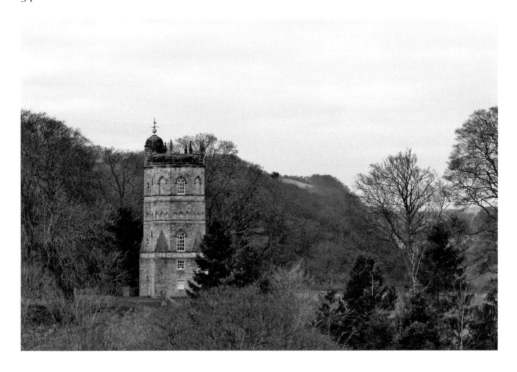

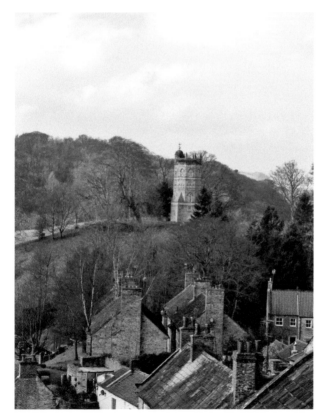

Above: Culloden Tower.

Left: Culloden Tower over the rooftops.

of Sedbury, but later in the early 1630s it was sold to the Nortons and 1651 it came into the possession of Sir John Yorke of Goulthwaite and Richmond through marriage. The building and grounds remained with the Yorke family until 1824. The house, which stood closer to the river at the foot of the hill, was generally known as Yorke House (also known as The Green) until it was demolished sometime between 1824 and 1827.

The tower was built in 1746 by the Yorke family to celebrate the victory of the Duke of Cumberland's army over Prince Charles Edward Stuart and the Jacobites at Culloden Moor. Daniel Garrett, a renowned architect, is believed to be responsible for the construction, which was originally built as a banqueting house and formerly known as the Cumberland Temple or simply The Temple. The tower actually stands on or close to the site of Hudswell Tower, a building dating from before 1354 that was erected by William de Huddeswell of Richmond and had been demolished by the 1730s.

Culloden Tower is now owned by the Landmark Trust, who renovated it from the sad state of neglect it had fallen into over the years. The Landmark Trust now rent it out as holiday accommodation.

Of interest is the stone walled garden to the north-east of the park, which is thought to have been a menagerie (collection of animals) with a building on the site from 1769, but after the demolition of the main house this building was modified to become a dwelling called Temple Lodge.

Aske Hall

Aske Hall began as a fifteenth-century pele tower and an added sixteenth-century hall, which was owned by the de Aske family until it passed by marriage to the Bowes family around 1522. In 1627, Sir Talbot Bowes sold the hall to Sir Thomas Wharton, whose family owned the estate for 100 years when it was sold to Sir Conyers D'Arcy. The estate was sold in 1763 to Sir Lawrence Dundas, who employed Lancelot 'Capability' Brown to carry out changes to the landscape between 1761 and 1813. Sir Lawrence's son was created the 1st Earl of Zetland in 1838 and the hall continues in the private ownership of the family to this day.

The wings are thought to date from the seventeenth century and the entire building was remodelled in the early to mid-eighteenth century. Further alterations were undertaken by Ignatius Bonomi in the nineteenth century and further work was carried out by Claude Phillimore in the twentieth century. A hundred yards north-west of the hall is a courtyard and stable block designed by John Carr and built in 1763.

The gardens are quite stunning and on the south-east side of the hall there are lawns that are divided from the park by a ha-ha wall, which has a balustrade and central stone steps leading down into the park. There are views over the park to a lake with a temple on its far shore with views into the distance. The whole estate is covered with wooded walks, open grassland and terraced walks.

On Pilmoor Hill is the Oliver Duckett, a 'folly fortress' or a castellated eye catcher, which is said to have been built from some stone retrieved from Richmond Castle. It is Grade II listed and is basically a round bastion tower with gun ports. It is actually thought to have been built in the mid-eighteenth century by Sir Conyers D'Arcy, rather than part of the Capability Brown design.

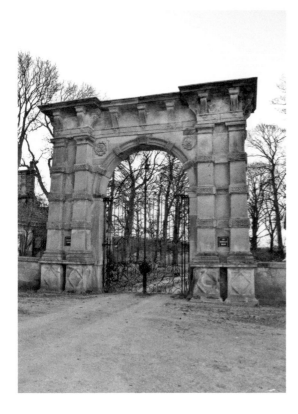

Left: Aske entrance gate.

Below: Oliver Duckett Tower.

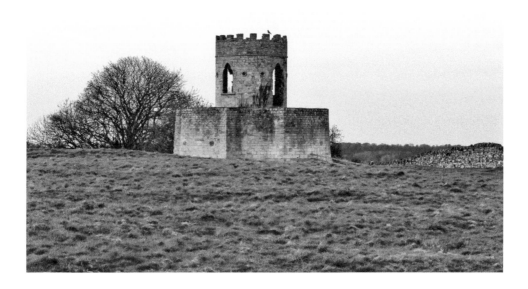

Marrick Priory

The priory of Marrick was originally founded by Roger de Aske, Archbishop of York, with the consent of Conan, Earl of Richmond, sometime between 1154 and 1158. The founder granted the Church of St Andrew of Marrick with a carucate (medieval measure of land) of land with Earl Conan confirming the gifts of Roger de Aske. As well as lands in Marrick, the convent received many other donations from the adjoining villages and also the hospital known as the Spital on Stainmoor, which was given by Ralph, lord of Moulton.

The priory was subject to strict rules, 'the prioress was to be affable to her nuns, treat them kindly, correct their excesses privately in chapter' and to inflict the same punishments for 'equal faults'. No one could go out unless the 'sickness of friends or some other worthy reason demanded it', and must be escorted by a 'prudent and mature nun', with a fixed time for return. The nuns must not sit with any guests in the cloister after curfew, and were not to remain alone with a guest after others had left. The guests were not to stay more than one night because 'the means of the house barely sufficed for the maintenance of the nuns, sisters, and brethren.' Nobody could be admitted without the bishop's licence and if they were admitted, that person would be 'expelled from the house, without hope of mercy, and the prioress would be deposed, and any other nuns who agreed would be condemned to fast on bread and water for two months, Sundays and festivals exempt'.

Very little is known of the priory until the Dissolution of the Monasteries and for some reason it was exempted from dissolution with the other lesser monasteries. This situation only lasted a few more years as on 17 November 1540 it was surrendered by Christabella Cowper and the sixteen nuns remaining on the site. The prioress received a pension of 100s and the other nuns receiving lesser and varying amounts.

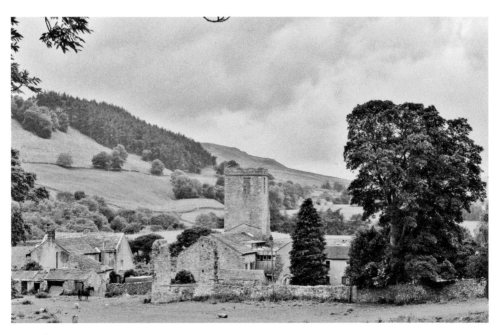

Marrick Priory.

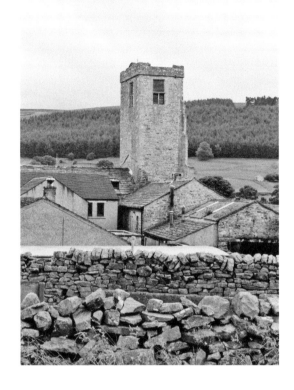

Marrick Priory Tower.

A list of the Prioresses of Marrick as known:

Agnes, *c.* 1200
Alina, *c.* 1230
Isabella Surrais, 1250–63
Margaret, *c.* 1282
Alice de Helperby, *c.* 1293
Juliana, *c.* 1298
Margaret, *c.* 1321
Elizabeth de Berden, *c.* 1326
Elizabeth, *c.* 1351
Maud de Melsonby, *c.* 1376
Elizabeth, *c.* 1391
Agnes, *c.* 1400
Alice de Ravenswathe, *c.* 1433
Cecilia Metcalf, *c.* 1464, died 1502
Agnes Wenslawe, *c.* 1502, died 1510
Isabella Berningham, *c.* 1511, died 1511
Christabella Cowper, *c.* 1530

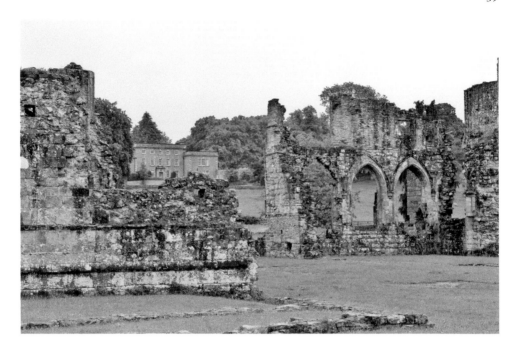

Above: Easby Abbey with Easby Hall in background.

Right: Easby Abbey.

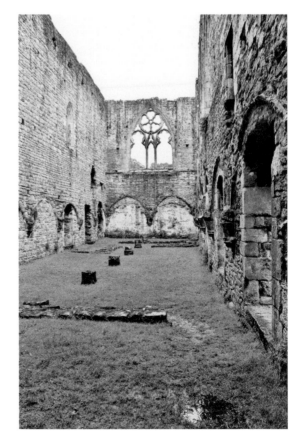

Easby Abbey

Around 1.5 miles south of Richmond, on the southern side of the River Swale, stands one of the best-preserved Premonstratensian monasteries in Britain. The location may have been part of a pre-Norman religious community based on the existing parish church of St Agatha at Gilling West. The hamlet of Easby is mentioned in the Domesday Book of 1086 as 'Asebi', which was held by Enisan Murdac, who was a vassal of Alan the Red.

The Premonstratensian order was founded in 1121 in France and followed the Rule of St Augustine, which meant the canons (not monks) could serve their communities by preaching, teaching and charitable work. This also meant they could serve as a parish priest and had the authority to celebrate mass and administer sacraments.

Easby Abbey was founded around 1152 by Roald, a constable of Richmond, who granted a modest new endowment of land, adding to the assets of the existing minster community. The abbey's benefaction rose over the years, increasing their land increasing their livestock, mainly sheep. The abbey seems to have prospered in the late twelfth century and the number of canons increased, including the expansion in 1198 to Egglestone Abbey in nearby Teesdale, which was founded as Easby's only daughter house. Easby's original buildings were also replaced at this time but on a much grander scale and only parts of the buildings can still be traced to before the late twelfth century. The descendants of Roald continued to hold the constableship of Richmond and the lands attached during this period, but during 1301 and 1321 they began to lose influence and patronage passed to the Scrope family, who were great landowners based at Bolton Castle in Wensleydale. The Scropes were responsible for enlarging the abbey by further grants of land and the 'community was to support 10 additional canons, two chaplains and 22 poor men'.

In 1320, the abbot was appointed as one of several to audit the accounts of the collectors of a 'tenth' for the Scottish War, which had been promised by Edward II and 'paid to the Scots ' as part of the truce agreed with them.

In the late fifteenth century, Richard Redman, Abbot of Shap and later Bishop of Ely, and the principal of the Premonstratensians in England, visited the abbey on a regular basis. In 1482 Redman found that a John Nym was a fugitive from the community who was accused of having improper relations with a widow. He was later found to be innocent and continued to be involved with the community. He also reported the community was in debt but the buildings were in a reasonable state of order and well provided with food.

In 1535 when the abbeys were being suppressed by Henry VIII and Thomas Cromwell, Abbot Robert Bampton (1511–36) restated the rights of the Scropes as patrons and the abbey continued as others were closed down. However, the writing was on the wall, and with a community down to just eleven canons, in 1536, the abbey was dissolved and its lands were let to Lord Scrope of Bolton for £300.

With Easby as the burial place of the Scrope family, it seems strange that they ordered the demolition of the church, but by 1538, most of the buildings had been stripped of their lead roofing and were partly demolished. Perhaps the church was ruined as part of the royal command to prevent the religious house being used again and ensuring a permanent closure.

Ownership of Easby continued with the Scrope family until 1630 when through the female line and marriage the Howes inherited the Easby estate. Though they kept the name Scrope, it was suffixed by Howe, and in 1700 Sir Scrope Howe sold it to

Bartholomew Burton, whose son became an MP and Governor of the Bank of England. The abbey passed through several different hands in the eighteenth century before being bought by Robert Jaques in 1816, who had amassed his fortune through the East India Company. The family continued to own the abbey until 1930, when they were taken into guardianship by the Ministry of Works.

Today we think of these religious houses as being the home of pious, gentle and kindly souls. This is simply not true, an example of which took place in 1284 when a complaint was made by John de Hellebeck and John de Bellerby that the abbot and his fellow canons had sabotaged a mill at Bolton-on-Swale. Apparently the abbot claimed an annual rental of 2s from the mill, claiming it was a gift from Robert de Hellebeck. The jury found that the abbot's servants had stripped off the iron and other goods from the mill, thereby rendering it unusable. The verdict was given against the abbot, and the damages were assessed at 10s. These men were simply money-making vandals, whose main devotion was to profit rather than saving the souls of men.

The canons at St Agatha's did not take the dissolution without resistance, and trouble promoted by them caused Henry VIII to write to Norfolk, sent to quell rebellion, to 'without pity or circumstance, now that our banner is displayed, cause the monks to be tied up without further delay or ceremony'. It is understood 'tied up' meant to be hung.

Abbots of St Agatha's:

Martin, *c.* 1155
Ralph, *c.* 1162
Geoffrey, *c.* 1204
Elias, *c.* 1224
Robert de St. Agatha, *c.* 1230
Roger de St. Agatha, *c.* 1237
Henry, *c.* 1241
William, *c.* 1255
John de Novo Castro, *c.* 1260
Thomas, *c.* 1302
Richard de Bernyngham, *c.* 1302
William de Ereholm, *c.* 1307
Roger de Walda, *c.* 1311
William de Burelle, *c.* 1311
Dom. Philip de Siggeston, 15 June 1315
Nigel de Ireby, 25 Aug. 1320
John de Percebrigg, 22 July 1328
John de Thexton, *c.* 1330
Thomas de Haxley, or Harley, 16 October 1345
William Isaac, *c.* 1375
John, *c.* 1392
William Langle, *c.* 1412
Robert Preston, *c.* 1422
Thomas. Rayner, 11 September 1449

Richard Hilton, 11 September 1459
Robert Preston, occurs 1469–70
William Yorke, 4 April 1470–75
Roger de Newhouse, 28 December 1475
William Ellerton, *c.* 1478
William Clintes, *c.* 1491
William Lingard, 6 March 1492
Robert Bampton, 16 October 1511

Richmond's Obelisk

In Richmond's marketplace there used to stand the old market cross, as well as the stocks and pillory, before being replaced in 1771 by the new market cross, also known as the obelisk. It is said to have been modelled on the Adelphi Water Tower on the south bank of the River Thames in London.

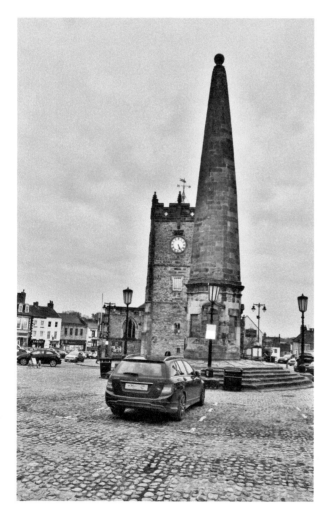

The obelisk in Market Place.

A cross was erected in market towns where trading was carried out to represent 'the sanctity of the bargain' and to signify fair dealing. Richmond's cross was described as the 'greatest beauty of the town', sitting high on a plinth protected by a 6-foot-high richly ornamented wall covered by shields of the Fitz-Hugh, Scrope, Conyers and Neville families. Each of its corners was apparently decorated by a resplendent stone dog sitting on its hind legs.

It was in 1583 when a pipeline of hollowed-out elm trunks was built to bring water from Aislabeck springs to a well head in the marketplace. An example of the elm trunks can still be seen in the Richmondshire Museum, a surprising survivor from when they were replaced by lead in 1749.

It was 1771 when the Corporation of Richmond employed Robert Plummer to design a new market cross and George Branson, a local mason, to build it, and they stipulated it must be complete by 10 October 1771. The obelisk is built on a large stone chamber or cistern designed to hold nearly 9,000 gallons of spring water. Due to the growing population, in 1812 another reservoir was dug at Aislabeck, near the old racecourse, and was topped by a stone well head inscribed with the name of the mayor, William Close.

The obelisk bears the inscription: 'Rebuilt AD 1771 Christopher Wayne Esq Mayor'.

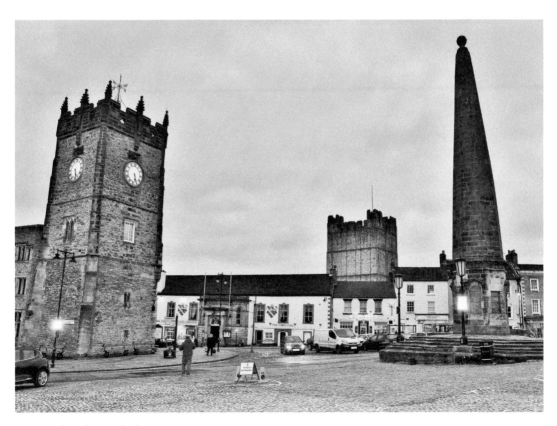

Market Place at dusk.

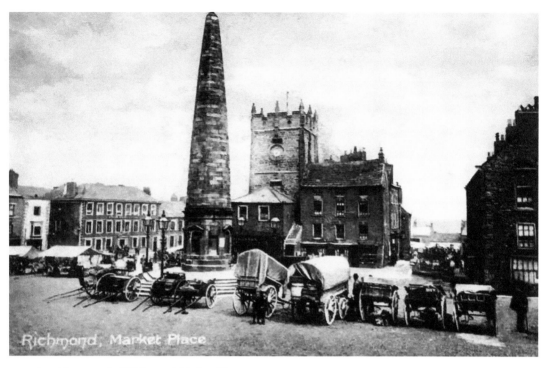

An old postcard of Richmond Market Place.

The Grove, Frenchgate, Richmond

The Grove is a large Grade II-listed red-brick mansion set back from the road with a double stepped stone stair up to the garden path. The house was built in 1750 by Caleb Readshaw (1675–1758), a mayor of Richmond and a wealthy merchant who developed the lucrative trade of exporting locally knitted wool caps and stockings to the Low Countries. The name of the house supposedly came from a grove of trees that were once in the rear garden. Red bricks were used in the construction because they were more fashionable than stone and were made in a nearby kiln. The house is Georgian in style and stands in around ½ an acre of land. The building has been renovated and is now made up of separate apartments and quoted as retaining 'part old worldly, part grand traditional charm and original features'.

Trinity Church, Market Place

Evidence suggests the Holy Trinity Chapel in the Market Square was only a chapel and not the parish church. It seems the chapel is first mentioned in 1330 as 'Holy Trinity Chapel, Richemund' but now serves as the Green Howards Museum.

There is a curfew bell in the tower with no date, but an inscription in black lettering *'Omne super nomen i.h.s. est venerabile nomen'* basically translated as 'In the name of the revered Christ'. There is a theory that the bell ringer used to live in the tower, and the bell had been modified to enable the ringer to ring it while still in bed. There may have been a graveyard around the chapel at some time as some gravestones have been used as lintels in one of the windows.

Above: The Grove, Richmond.

Right: Market Place, off Friars Wynd.

Narrow streets around the castle.

Tower Street next to the castle.

Frenchgate.

Newbiggin.

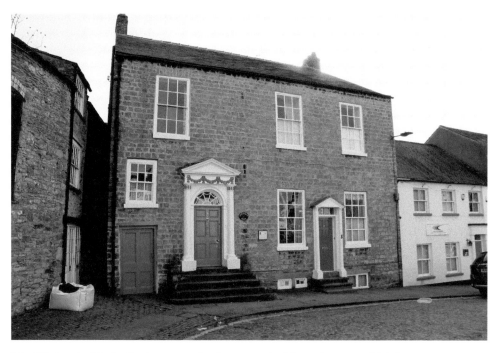

John Wesley, the Methodist, is supposed to have preached from the steps of this house.

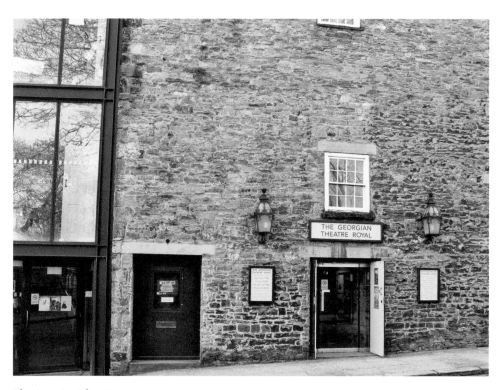

The Georgian Theatre.

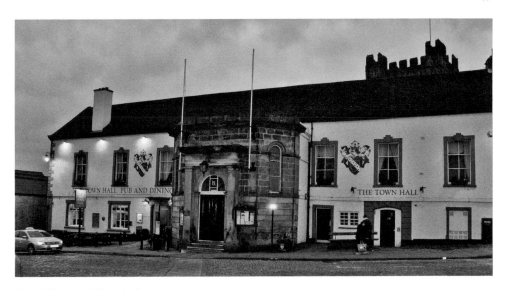

The old Town Hall at dusk.

Greyfriars Tower

North of the castle and town centre are the Friary Gardens, which used to be part of the medieval Greyfriars Monastery, but all that now remains is a tower and a few fragments of the walls of the chancel and south chapel. The monastery was founded by Ralph Fitz Randolph in 1258, a knight of Middleham and Barton, who was later buried at Coverham Abbey near Middleham. Evidence suggests the church consisted of a choir, nave and south chapel, but with the monastic buildings just to the north. The remaining tower, built in the fifteenth century, is believed to have replaced an older one, perhaps built in wood, and now forms the centrepiece of the parkland.

In all likelihood the first buildings would have been constructed of timber based on St Francis' ideals of poverty and the need for humble churches. This ideal had changed by the late thirteenth century when more lavish stone buildings very similar to other orders were erected. In 1364, a grant of 4 acres 'for the enlargement of the house' and another in 1383 for 1½ acres of meadow added to the income of the order. The Friary Gate was added to the town wall to allow access from the town to the friary and may have been due to the friary having a reliable water supply.

As with other monasteries, the friary was dissolved in January 1539 with only fourteen monks and a warden remaining. The friary estate ended up being leased to Ralph Gower, then later by Sir Timothy Hutton until 1634 when it passed to the Robinson family until the end of the nineteenth century. Some of the friary buildings continued to be used by the owners and the Hutton family had a house at the site in the early seventeenth century, probably modified from one of the monastic buildings. Old documents and maps still show this house as well as other buildings around the church tower. It was not until the late eighteenth century that the house and grounds were refashioned to include pleasure gardens and the bell tower as a romantic garden feature. It seems at this time the remaining medieval buildings would have been removed and the stone sold off, now lost to history.

Left: Greyfriars Tower and war memorial.

Below: Greyfriars Tower.

5. People

The population of Richmond has grown significantly over the years and stood at 8,413 in 2011. In 1821, the population was 3,546, and had only grown to 4,216 by 1891. In 1911 the number of souls living in Richmond had actually dropped to 3,934, possibly due to the lack of industry in the area and expansion of towns in the north-east of the country.

DID YOU KNOW?
When the county boundaries were changed in 1974 over one million people no longer lived in Yorkshire.

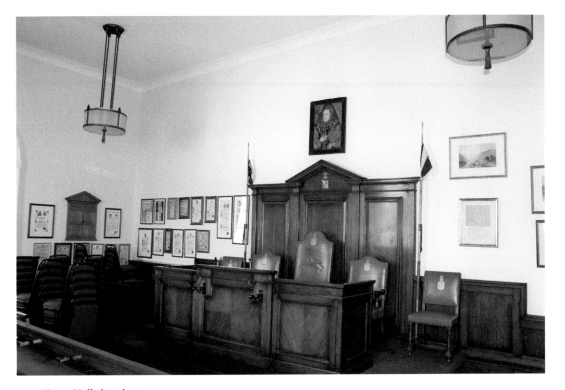

Town Hall chambers.

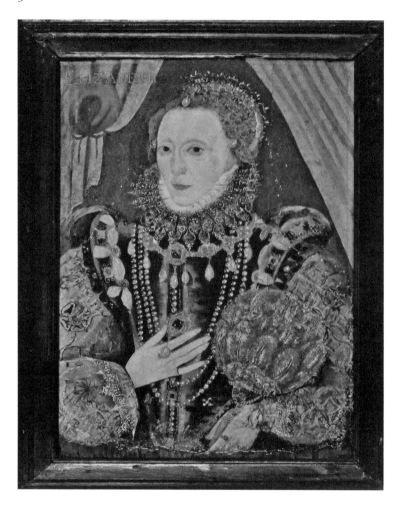

Portrait of
Elizabeth I in
the Town Hall
chambers.

In the 1823 *Gazetteer* for Richmond, there are twenty-three inns or taverns listed serving a population of only 3,546. This equates to 154 men, women and children for every public house.

Bishop Blaize, Market Place. Landlord: Robert Raw
Black Bull, Low Row. Landlord: Mrs Wilkinson
Black Lion, Finkle Street. Landlord: Thomas Walker
Black Swan, Green. Landlord: Thomas Cambadge
Board, Frenchgate. Landlord: William Walker
Fleece, Friars Wynd. Landlord: J. C. Ibbotson
Kings Head, Market Place. Landlord: M. Yarker
Lord Nelson, Frenchgate. Landlord: F. Blades
Lord Wellington, Market Place. Landlord: J. Foster
Nags Head, Pinfold Gr. Landlord: William Radcliff
Punch Bowl, Market Place. Landlord: Jane Hall

Queen Catharine, Low Row. Landlord: John Rushforth
Red Lion, Finkle Street. Landlord: John Wilson
Ship, Castle Hill. Landlord: John Clark
Ship, Frenchgate. Landlord: Ralph Foster
Shoulder of Mutton, Millgate. Landlord: E. Clement
Talbot, Market Place. Landlord: Thomas Lambert
Three Tuns, Bridge Street. Landlord: W. D. Dawson
Town Hall Tavern, Market Place. Landlord: T. Waller
Turf Coffee House, King Street. Landlord: Revd Petch
Unicorn, Newbiggin. Landlord: John Carter
White Hart, Bridge Street. Landlord: Jas Blenkiron
White Swan, Frenchgate. Landlord: Robert Brown

The Talbot Hotel.

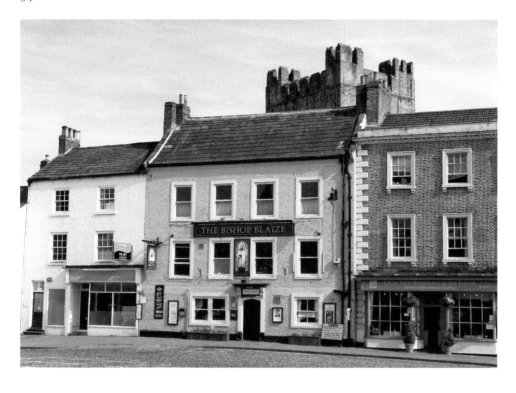

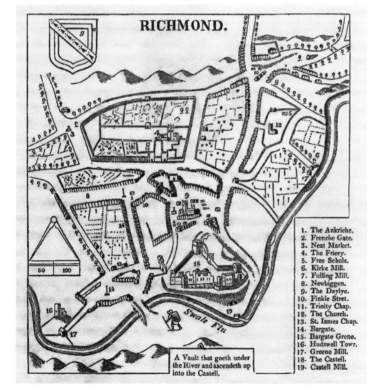

Above: The Bishop Blaize.

Left: A map of Richmond by John Speede, 1610.

John Alexander Scott

Scott was a chaplain in the Royal Navy, the son of Robert Scott, a retired lieutenant in the navy, and nephew of Commander, later Rear-Admiral Alexander Scott. His father died when he was only two years old and two years later in 1772 his uncle took the boy to his posting in the West Indies where for the next four years he lived with the governor and his wife of the Leeward Islands.

In 1776 his uncle lost his left arm in battle, which compelled him to return to England and retire from active service. It seems John returned with him and was sent to gain an education, ending up at St John's College, Cambridge, in 1786 where he finally graduated with a BA in 1791. In the following November he was ordained a deacon to a small curacy in Sussex, and in November 1792 was ordained a priest.

Due to his college debts, in 1793 he accepted the offer of a warrant as chaplain of the Berwick with Captain John Collins, an old friend of his father. What followed was an exceptional career in the navy and he was regularly in the service of Horatio Nelson. On the 15 September 1805 he sailed with him once more on the *Victory*, but during the Battle of Trafalgar, 21 October, he attended to the dying admiral's last hours and receiving his last wishes. On the return of the *Victory* to England he attended the coffin as it lay in state at Greenwich until Nelson was finally laid in the crypt of St Paul's.

In 1816 Lord Liverpool presented him with the living of Catterick in Yorkshire, and at the same time he was appointed chaplain to the Prince Regent, which gave him the right of holding two livings. From this time he lived principally at Catterick, engaged in the duties of his profession and accumulated a large library. He died at Catterick on 24 July 1840, and was buried in the churchyard of Ecclesfield, near Sheffield.

Henry Jenkins

Recorded in the register of the St Mary's Church in Bolton-on-Swale is the burial of Henry Jenkins, who died at the age of 169.

Henry claimed to have been born in 1500, though parish registers were not required to be kept until 1538 when they were introduced by Thomas Cromwell (advisor to Henry VIII). He lived at Ellerton-on-Swale and claimed to have been butler to Lord Conyers of Hornby Castle, carried arrows to the English archers at Flodden Field (1513) and swam rivers at the age of 100. Chancery Court records show that in 1667 he claimed under oath that he was aged 'one hundredth fifty and seaven or thereabouts'.

In 1743 the local inhabitants commemorated Henry Jenkins with a memorial inside the church and erected an obelisk in the churchyard.

Philip, Duke of Wharton

The Wharton family had long been associated with the area and Philip inherited the estates at the age of sixteen. Leaving the estates in the care of others he went travelling and encountered James Francis Edward Stuart, also known as the 'Old Pretender' and became a firm Jacobite. A lothario and seeker of pleasure, Wharton is credited with founding the first Hellfire Club, but in 1720 the South Sea Bubble stock market crash occurred and he was crippled with debt. In 1721, he conveyed the manors of Healaugh and Muker to trustees for the payment of his debts.

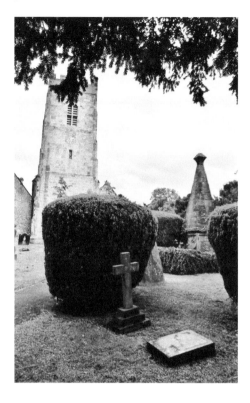

Bolton-on-Swale Church and memorial to Henry Jenkins.

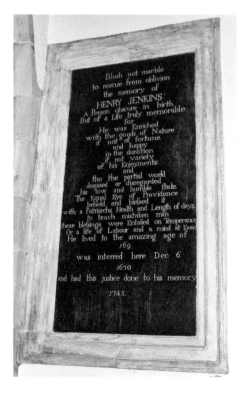

The memorial to Henry Jenkins in Bolton-on-Swale Church.

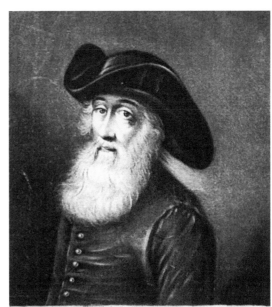

HENRY JENKINS, who lived to the Surprizing Age of 169 Years.

Henry Jenkins.

Worse was to come when he sold back his title to George I and took up a position as a lieutenant colonel in the Jacobite forces fighting the English in Europe. This led to him being tried for treason in England and he would never return home. In 1729 the duke was attainted and outlawed for high treason, and all his estates were forfeited. In 1731, as an alcoholic, he died poor and neglected in a Spanish monastery.

The Hutton Family of Marske

The Hutton family go down in history as the only family to produce two archbishops. Matthew Hutton (1529–1606) was Archbishop of York from 1595 to 1606 and another Matthew Hutton (1693–1758) served as Archbishop of York from 1747 to 1757, and Archbishop of Canterbury from 1757 to 1758, when he died in office.

The Hutton family not only served the church but also the horse racing fraternity and they are connected to the breeding of racehorses at Marske from around 1700. A John Hutton is believed to have acquired Royal Colt and Grey Barb around this time and both are described as significant horses in the early breeding pedigrees. A Byerley Turk mare was bred to both the Royal Colt and the Grey Barb, establishing a breeding family that continues to this day.

The Manor of Marske was purchased by Sir Timothy Hutton before 1629 and it passed to his son Matthew (1597–1666), followed by a series of John Hutton's over the next couple of hundred years before being inherited by a grandson in the mid-1800s.

The extraordinary monument to Matthew Hutton, Archbishop of York, in the York Minster is well worth a visit.

Samuel and Nathaniel Buck

Samuel Buck and his brother Nathaniel were English engravers and printmakers said to have been born in Richmond in the late 1600s, though there is some doubt, and Hauxwell, south of Richmond, has also been suggested as their birthplace. They are best known for their extensive depictions of ancient castles and monasteries. Samuel was the more prolific but when the brothers worked together, they were usually known as the Buck brothers.

Between 1726 and 1753 the brothers were engaged by wealthy patrons and created 423 engravings of ancient monasteries, abbeys, castles and ruins known as 'Antiquities'. They also produced eighty-one views of towns and cities in England and Wales.

Samuel survived his brother and spent his last days dependent on subscriptions from his friends, eventually dying at the age of eighty-three in 1779. He and his brother's catalogue of work are now considered a valuable asset to the nation, celebrated by historians and collectors alike.

Alan Broadley

Born in Leyburn in 1921, Flight-Lieutenant Alan Broadley died on 18 February 1944 during Operation Jericho, a daring mission to free 500 French resistance fighters imprisoned in Amiens prison where they were to be executed by the Gestapo.

Broadley had many links to the area. His mother had run the Terrace House Hotel in Richmond and Alan attended Richmond Grammar School before joining the RAF prior to the outbreak of the Second World War. As a navigator he flew more than a hundred missions including operations with the SOE (Special Operations Executive).

He and his great friend Group Captain Alan Pickard were chosen to lead one of the war's most audacious, daytime, low-level raids. The objective was to bring down the prison walls to free the resistance fighters being held within. They would attack the prison using the De Havilland Mosquito, one of the finest and fastest light fighter-bombers of the war. Precision would be the objective as they attempted to destroy the northern and eastern walls, allowing the inmates to breakout. They were also ordered to bomb the German mess hall during lunchtime in the hope of achieving the maximum level of casualties among the prison guards. Once the initial wave attacked the prison, they had to fly back over the target and assess the damage; if insufficient damage had been caused they would call in a second wave. The operation inspired the 1969 film *Mosquito Squadron* starring David McCallum.

The mission was relatively successful and the walls were damaged to the extent that at least 200 prisoners were escaping into the nearby woods and fifty guards had been killed. However, as the Yorkshire airmen were returning to the target to assess the damage, they sustained a direct hit and crash-landed into a wood. Broadley was only twenty-three at the time of his death, leaving a family and fiancée behind to mourn him.

Barry Heap

While researching this book in Richmond, I asked a gentleman who was associated with an event at the town hall if there was any resident of the town I should mention in the book. Expecting a figure from history, he simply replied 'Barry Heap', and proceeded to explain a little further.

De Havilland Mosquito at Elvington Air Museum.

Mayor's Chambers.

Penfold postbox, *c.* 1866–77.

1732 plaque on the Town Hall.

Barry is a well-known face and voice from the town who has been the town's mayor, a councillor and the town crier. The proclamations as town crier are given at points north, east, south and west in the centre of the town. His rhyming verse can be heard on most Sundays during the summer. So if you are in the town and you hear shouting in the streets, fear not, it may simply be the local news being declared in a manner you are unaccustomed to.

James Tate

James Tate was the headmaster of Richmond School and was celebrated for his inspirational teaching at a time when headmasters generally ruled by fear. Under his tutorship between 1812 and 1833, an average of six pupils a year progressed to university, with twenty-one of them becoming fellows, thirteen of them at Trinity College, Cambridge. They became so respected that they were known as 'Tate's invincibles'.

Tate rejected corporal punishment for his pupils, preferring the path of inspiration and mentoring. One of the most famous former scholars of the school is Charles Lutwidge Dodgson, who was at the school between 1844 and 1846. Dodgson is more widely known by the name Lewis Carroll, author of *Alice in Wonderland*.

In 1850, his son, James Tate II, requested that a new building be erected in honour of his late father and the new building opened on the 27 September 1850 as the 'Tate Testimonial'. It later became Richmond Lower School but was closed as an educational establishment in July 2011 as the new building on Darlington Road would accommodate all the secondary education students from Richmond.

Willance's Leap

Just to the west of Richmond is Whitcliffe Scar, a cliff overlooking the Swaledale valley, and atop of this precipice stand three stones, two of which bear the words of Robert Willance written in 1606. This area is known locally as Willances's Leap.

Robert Willance was a local entrepreneur with interests in lead mining on his land at Clints. In November 1606, while out riding, a thick mist descended and he became lost as he tried to return to Richmond. Some say his young horse panicked and leapt from the edge of Whitcliffe Scar, falling over 200 feet to the valley below. The horse was killed but somehow Robert survived, but with one of his legs broken. He knew he would not survive the night unless he acted quickly, so he used his hunting knife to slit open the horse's belly and inserted his fractured leg. This act probably saved his life, as the warmth would

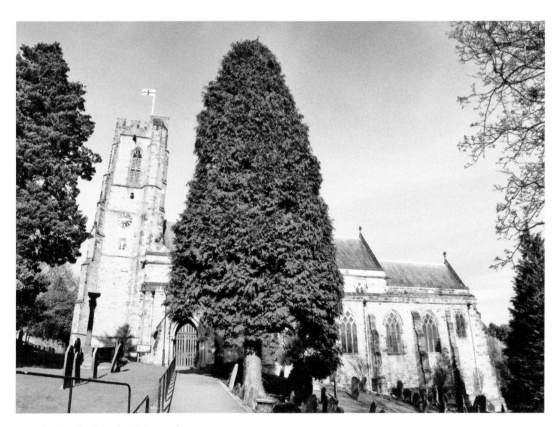

St Mary's Church, Richmond.

Swale House.

have delayed the onset of gangrene. Though his leg was later amputated, he had at least survived the ordeal.

He erected a stone to commemorate his astounding escape, inscribed with the words 'Hear Us – Glory be to our Merciful God who Miraculously Preserved me from the Danger so Great.' The stone was replaced in 1734, and again in 1815, as well as in 1843. An obelisk was erected in 1906 to commemorate the 300-year anniversary celebrations held in the town. A third stone was placed in 2006 to celebrate this 400-year-old story.

A door was built in the bottom garden wall of his Frenchgate house directly into St Mary's churchyard. This gave him easy access to the church he attended until he died in 1616. He was buried close by and a fragment of stone bearing his words still remains in the churchyard.

He was made alderman of Richmond in 1608 and left money for the poor of the town. He provided for his wife and relatives, left bequests for his illegitimate son and daughter and to the alderman and burgesses of Richmond he left a loving cup, which remains in Richmond's Green Howards Museum.

Lewis Carroll

Charles Lutwidge Dodgson, better known by his pen name Lewis Carroll attended Richmond Grammar School in around 1844 for eighteen months while his father was the rector at Croft-on-Tees. Though the school was only 10 miles from his home, he boarded at

the headmaster's house, which enabled his parents to visit on a regular basis. He settled in well and received an excellent foundation for his education, excelling in mathematics.

In 1846, on his fourteenth birthday, he was enrolled at Rugby School, but as a shy and sensitive boy with a stammer, he suffered from bullying by the older boys. Despite this he achieved high standards in his school work, winning prizes and still shining at mathematics. He suffered from a number of illnesses during the year including whooping cough in the spring and later he contracted mumps, which this left him somewhat deaf in his right ear.

He left Rugby in December 1849 and was accepted at Christ Church College, Oxford, beginning in the May 1850, and he would later become one of this countries most celebrated writers, particularly famous for his fantastical story *Alice in Wonderland*.

Rear-Admiral Sir Christopher G. F. M. Cradock

Cradock was born on 2 July 1862 at Hartford Hall and began his career with the British Navy in 1875 at HMS *Britannia* (naval school) in Portsmouth. He became a British officer of the Royal Navy and earned a reputation for great gallantry throughout his service. During the early part of the First World War, while his squadron was operating in the South Pacific, he was killed during the Battle of Coronel in an engagement with the German navy off the coast of Chile. Cradock's flagship HMS *Good Hope* was sunk with all hands including Cradock himself. There is a memorial to him in St Agatha's Church in Gilling West and another in the York Minster.

A memorial in Gilling West church.

The memorial in York Minster reads:

TO THE GLORY OF GOD
AND IN MEMORY OF
REAR ADMIRAL SIR CHRISTOPHER CRADOCK.
KNIGHT COMMANDER OF THE ROYAL VICTORIAN ORDER.
COMPANION OF THE MOST HONOURABLE ORDER OF THE BATH.
WHO GALLANTLY UPHOLDING
THE HIGH TRADITION OF THE BRITISH NAVY
LED HIS SQUADRON
AGAINST AN OVERWHELMING FORCE OF THE ENEMY
OFF CORONEL ON THE COAST OF CHILI,
AND FELL GLORIOUSLY IN ACTION
ON ALL SAINTS' DAY 1914
THIS MONUMENT IS ERECTED BY HIS GRATEFUL COUNTRYMEN.

Henry Francis Greathead

Henry Francis Greathead was born in Richmond in 1757 to John Greathead, who was the supervisor of Salt Duties at Richmond until the family moved to South Shields in 1763. His early years are a little confused but it is believed he apprenticed as a boatbuilder before spending time as a ships carpenter in the Navy between 1778 and 1783.

Since the 1770s there had been attempts to provide a better method to rescue seafarers, and although Lionel Lukin patented a lifeboat, it took a tragedy at the mouth of the Tyne in 1789 to realise a special vessel for saving lives from a shipwreck was required. Some businessmen from Newcastle offered a prize of 2 guineas for the best plan or model of a lifeboat. A local parish clerk called William Wouldhave was offered half the prize money and Henry Greathead was asked to build a lifeboat using the best features of Wouldhave's design. The boat called the *Original* was launched in January 1790 and ended up in service for over forty years, saving hundreds of lives.

Another boat was built in 1802 – named *Zetland* – and was brought to Redcar in the same year. She remained in service until 1880 and saved over 500 lives with the loss of only one crew member.

Greathead had successfully petitioned parliament in 1802 with the claim that he had invented a lifeboat in 1790, and he was awarded £1,200 for his trouble. His claims may have been contested but he did build thirty-one boats, saved many lives, and made the use of shore-based rescue lifeboats the norm.

Ralph Hedley

Ralph Hedley (1848–1913) was born in Richmond but brought up in Newcastle, where he studied art and design, and at thirteen he began as an apprenticeship to Thomas Tweedy in his carving workshops. He became an artist, a member of the Royal Society of British Artists, and was well known for portraying scenes of everyday life in the north-east of England.

He started a business in New Bridge Street, Newcastle, later moving to No. 52 St Mary's Place and eventually passed on the business to his sons. Examples of his wood carvings are found in St Nicholas' Cathedral and St Andrew's Church in Newcastle upon Tyne. Many of Hedley's oil paintings can be seen in the Laing Art Gallery in Newcastle.

Charles Grey

Charles Grey was educated at Richmond Grammar School and became prime minister in 1830–34. He was a member of the Whig Party and was significantly involved in the great reforms of the period. These included the Great Reform Act of 1832, which introduced important changes to the electoral system and attempted to reduce corruption, especially rotten boroughs where the electorate was so small it could be bought by the local lord for influence in Parliament. He was also involved in the Slavery Abolition Act of 1833, which abolished slavery throughout all the Empire, and as Earl Grey he had a tea, which uses bergamot oil as flavouring, named after him.

He is commemorated by Grey's Monument in the middle of Newcastle upon Tyne, which consists of a statue of Lord Grey standing atop a 41-metre-high column. The monument was struck by lightning in 1941 and Earl Grey's head flew off, landing on a passing tram below. Luckily no one was seriously injured but the head was badly damaged and it was another seven years before the head was actually replaced.

6. Events

Yorkshire Uprising

During the Yorkshire rebellion of 1489 the field of Gatherley was used as a meeting place for the rebels. It was a protest against the heavy taxation imposed by Henry VII to pay for his plans to assist Brittany in the region's efforts to maintain independence from France. In 1489, Parliament voted Henry £100,000 in his quest to support Brittany, but it had to be raised via taxation, causing resentment among all echelons of society because it was a form of income tax.

The tax was least welcome in Yorkshire, which still supported the Yorkist cause at heart, but they had also been badly hit by a poor harvest in 1488. They also believed that northern counties were exempted from the tax because they were expected to use their

View from the A66 road towards Richmond.

finances to defend the country from the regular invasions from the Scots. Henry Percy, Earl of Northumberland, presented their cause before the king but Henry was not willing to back down so early in his reign and would not listen to Northumberland's arguments. The earl returned north with nothing and was suspected of supporting the tax, leading a group of rebels led by Robert Chamber to confronted him at Cock Lodge near Topcliffe on the River Swale. During the confrontation there was a scuffle and Northumberland was killed.

The rebels, under their new leader, Sir John Egremont, a bastard son of the Percy family, marched towards York. Now numbering 5,000 men, and hoping to pick up support along the way, they stormed the city on 15 May. Their success lasted for only two days and they fled due to the reports that the Earl of Surrey was marching north. The king took command when he travelled to York for the trials of the ringleaders where only four were actually executed and altogether there were only sixty-six indictments.

Pilgrimage of Grace

The Pilgrimage of Grace was a major uprising against the Dissolution of the Monasteries, and though it began in Lincolnshire, it soon spread into Yorkshire and Richmond was a major centre of the uprising. It is noted that the 'Richmondshire men provided the banner of St Cuthbert behind which the Pilgrim army was first arrayed.' At Richmond Sir Christopher Danby and Lord Latimer were sworn in as leaders and in December 1536 the town's bailiffs restored the canons to Easby Abbey. A monk from Sawley Abbey, near Clitheroe, was visiting Richmond and was told by a group of townsmen 'Rather than our house of St Agatha should go down, we shall all die'. From this we can gauge that many people in the area would sympathise with these sentiments at the time; indeed, Richmondshire was known as a bed of resentment and agitation. Discontented crowds are recorded as gathering in Wensleydale, Sedbergh and Dent, owing to the plight of its monasteries and the dismantling of the Catholic faith.

As the rebellion spread the rebels met at Richmond before dividing into three groups, with one band travelling to Barnard Castle, another south and the other west. However, by the spring of 1537 the leaders of the Pilgrimage of Grace had missed their chance to defeat the forces of the Crown and on 22 February a vengeful Henry VIII wrote to the Duke of Norfolk, who was engaged in crushing the rebels. In the end Robert Aske, Lord Darcy, Thomas Percy and Robert Constable were arrested, convicted of treason and executed. Possibly fifteen or more Richmondshire inhabitants were hung including an Anthony Peacock at Richmond for 'stirring rebellion around Barnard Castle'.

The Rising in the North

In 1569, the Earl's Rebellion, better known as the Rising in the North, broke out when a large number of the northern nobility, gentry and people rallied to the old faith. Catholicism was rekindled when Mary, Queen of Scots, fled from Scotland to England in 1568 and placed herself under the protection of her cousin, Elizabeth. Mary was a devoted Catholic and a political rival in a Protestant England. Some of the Catholic north felt she

had the greater claim to the crown of England than Elizabeth, who was an illegitimate monarch according to the Catholic Church. Richmondshire had a major role to play in the rebellion and some local lords were protagonists in the events of 1569.

Initially Mary was housed at Workington Hall, then at Carlisle Castle, before being moved to Bolton Castle in Wensleydale, probably via the Penrith, Stainmore and Swaledale route. She was under the care of Lord Scrope before moving to Sheffield Castle, then Tutbury, and finally to Fotheringay, in Northamptonshire.

The insurrection began when Thomas Percy, 7th Earl of Northumberland, and Charles Neville, 6th Earl of Westmorland, planned to release Mary, with the aim of re-establishing the old faith and to remove most of Elizabeth's counsellors. The first meetings of the conspirators were held at the Earl of Northumberland's residence at Topcliffe where they drew up their manifesto.

Raising support in the north of England, the rebels marched to Durham and took over the city where the two earls entered Durham Cathedral with their followers. They tore up all the English translations of the Bible and all the Reformation prayer books before holding a mass with all the old ceremony. After ten days or so, they then marched south,to Staindrop, Darlington, Richmond and Ripon, gathering forces as they went until they numbered in excess of 5,000 troops.

The rebels set their sights on taking York but received a warning that the Earl of Essex had raised an army and was heading north. They retreated back to the Earl of Westmorland's Raby Castle estate in Staindrop and from there to Barnard Castle. Here Sir George Bowes of Streatlam held out against a siege for eleven days before some of his own troops jumped the wall to join the rebels and the resistance crumbled forcing Bowes to surrender.

The rebels headed to Clifford Moor, near Wetherby, and it was clear the army had reduced in number rather than gathering support along the way. The delay at Barnard Castle had allowed the Earl of Essex to reinforce and he marched out of York with 7,000 men, followed by another force of 12,000 under the Earl of Warwick and the Lord Admiral Clinton. At the crossing of the Tees at Croft, 17 December 1569, Sir George Bowes met the Earl of Sussex as the rebels retreated northward first to Raby Castle, on to Auckland, Hexham and finally to Naworth Castle. At Naworth, Lord Dacre, once a supporter, was conscious of the situation, gave them short shrift and they disbanded their forces. Many fled to Scotland and others were killed or captured as they tried to evade the queen's army.

The Earl of Northumberland was captured in Scotland and was handed over to Elizabeth in 1572 but not before being marched through Durham, Staindrop and Topcliffe. He was taken to York and beheaded at 'Pavement' in York on 22 Aug 1572. His head was displayed on Micklegate Bar (wall gate) for two years before being stolen one night, but his body was buried without memorial in the Church of St Crux, York. Lord Westmorland escaped to Flanders but died penniless and forgotten on 16 November 1601. Many others were dealt with very cruelly by the Earl of Essex and Sir George Bowes, who were responsible for the execution of sixty-six people at Durham and at York twenty-eight priests were hanged, disembowelled and quartered for practicing the Catholic sacraments. Others

were executed for harbouring priests, and one woman was cruelly pressed to death for the same crime. In all more than 800 were executed on the gallows, with fifty-seven noblemen and gentlemen attainted by parliament, and their estates confiscated.

Bloody This and Bloody That

When looking for potential areas of conflict in the dale, place names may be the first clue and with so many places called 'Bloody' and sometimes 'Surrender', the possibilities are obvious. Add to this finds of Roman military horse fittings, iron armour and battleaxes, the premise of violent times in these areas appears strong. Place names Bloody Wall, Bloody Stones and Bloody Vale add weight to the theory, and Surrender Bridge and Gallows Top may tell of the fate of some of the combatants.

In the early 1800s it was reported that several pieces of Roman military horse fittings, now in the York and the British Museum, were found in Fremington Hagg. In 1823 around a mile from the valley known as the Bloody Vale, iron armour and battleaxes were discovered. There is also a tradition that a battle was fought somewhere in the dale during the time of the Scottish Wars in the thirteenth and fourteenth centuries. Local tales abound of Scots attacking, kidnapping and pillaging the area and the discovery, in 1847, of seven bodies buried with all their trappings near Melbecks vicarage back up these word-of-mouth histories.

It is known that the Scots invaded the dale on many occasions between 1314 and 1347, raiding down from the Eden valley across Stainmore and heading up Teesdale or down to Swaledale to gather booty and generally cause mayhem in the dales.

Riding the Stang

There seems to be a local tradition of vigilantism or local justice depending on your point of view. One event reported as 'riding the stang' occurred in Richmond in November 1867, when, according to the information, 400 people turned up outside the house of a Mrs Moore in Frenchgate where for several nights they were involved in 'creating a violent noise and riotous conduct'. The crime of Mrs Moore is not recorded and the reasons for her misdemeanours are lost to time, but the local cruelty included her effigy being burned on the street. Eight men were fined for their part in the disturbance, but support for the action was confirmed by a whip round to help pay their fine, which was collected in the town.

Riding the stang is generally referred to as a punishment of victims of intimate partner violence, so we must assume Mrs Moore was abusing someone, possibly her husband. One case is also recorded occurring at Stainmore, when a married vicar fell in love with a much younger school mistress. The national story broke in 1900 when six local people appeared in court for lashing him to a gate and taking him to face his wife.

The Richmond Shilling

The Richmond Shilling is a tradition thought to date back to the Elizabethan era when the town paid a fee to the queen for the royal grant to hold a market. Queen Elizabeth

commanded that this fee should be distributed to the 'poor indigenous tradesmen and decayed housekeepers' at a time just before Christmas.

This tradition was maintained up until the 1980s but the value of this 'shilling' devalued over time and in the end, even the increased sum of 50p was felt derisory. Not wishing to stop the custom, the town council decided to mint a ceremonial coin instead, and the first Richmond Shilling was struck at the Birmingham Mint in 1986. Richmond Castle and the River Swale decorate one face while the other is adorned with the Richmond coat of arms and includes the Latin '*Mater Omnium Richmondiarum*' or 'The Mother of all Richmond's'.

The coin is actually offered to all the people of pensionable age in Richmond and a ceremony is held in the Town Hall to distribute the coins. A unique gift to the privileged elder citizens of the town and apart from the Queen's issue of Maundy Money, this may be the only town in the country to receive such an award.

Richmond Monks and the Sow of Rokeby

Included in a book by Edmund Bogg (a writer from Leeds who wandered the Pennines) he describes a curious satirical ballad known as 'The Felon Sow of Rokeby'. This ballad was supposedly written to illustrate the greed and rapacity of the monks of Richmond. It appears that Ralph de Rokeby, who lived in the time of Henry VII (1485–1509), had an extremely vicious and belligerent sow in his woods, whose lair was by the River Greta. This diabolical and ghastly brute was given by Sir Ralph de Rokeby, in a spirit of mischief, to the Friars of Richmond, on condition they themselves would come and remove her. So Friar Middleton set out, accompanied by two fellow monks, one of which, the ballad says, was called Peter Dale. At the end of their 12-mile journey from Richmond to Rokeby, they found the wicked sow lying under a tree and the story says she rose up to 'fight against the three'.

After a terrible struggle she was forced into a kiln hole, where they at last succeeded in placing a halter round her neck, at which she 'raved and roared' so furiously that the monks became frightened. The sow fought back and pulled them to and fro, knocking them off their feet. Peter Dale tried reading a book of gospels to the beast to calm her down but the 'sow would not Latin heare' and charged the three, dragging the rope from their hands. In the end the monks were completely vanquished and fled away up Watling Street, for the ballad says they had no succour but their own feet.

When the defeated monks arrived home and told their story of how they had fought a fiend in the likeness of a sow, Friar Theobald, the warden, was more determined than ever to capture her, so he engaged two of the boldest men that were ever born. One was named Gilbert and the other was a 'bastard son of Spain', who had killed many Saracens. On meeting the sow a terrible fight occurred, in which the Spaniard nearly lost his life but Gilbert overcame and 'felled her there'. He carried her back to Richmond on his horse like 'two paniers well made' and there was great rejoicing in the town with thanksgiving to God and St Francis for a noble victory.

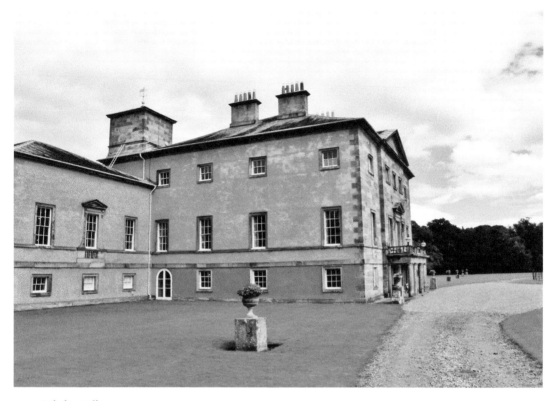

Rokeby Hall.

Secret Tunnels and the Drummer Boy

There is an enduring legend that speaks of a tunnel leading from the Richmond Castle to Easby Abbey and this myth is linked to another story about a drummer boy. The tale speaks of a group of soldiers discovering what looked like the entrance to a tunnel, but was so small that only the regimental drummer boy could squeeze through. They proposed to send the boy through the tunnel while beating his drum so they could listen and follow the sound. The plan worked for a time as they followed the sound towards Easby. The story says at around 3 miles along the tunnel the sound suddenly stopped and the boy was never heard of or seen again.

If the legend is true there could be many reasons why the young lad was lost: there could have been vertical shafts or the tunnel collapsed, but the story flourishes into a ghost story that grew and persisted through the years. Many people have described hearing the sound of drumming under the castle, by the river or near to the abbey.

Today there is a monument, known as the Drummer Boy Stone, to mark the place where the sound of his drumming stopped. Each year the story is celebrated in Richmond with children marching through the town dressed as the drummer boy in uniforms loaned by the Green Howards Museum.

Drummer Boy Stone.

Witchcraft on Gatherley Moor

Often reported in tales from Richmondshire is the discovery of some lead plates (tablets) found in a heap of stones on Gatherley Moor with strange inscriptions, scratches and grids of numbers. They also had the following engraving:

> I doe make this, that James Phillip, John Phillip his son, Christopher Phillip, and Thomas Phillip his sons, shall flee Richmondshire, and nothing prosper with any of them in Richmondshire.
>
> I do make this, that the father James Phillip, John Phillip, Arthur Phillip, and all the issue of them shall come presently to utter beggary, and nothing joy or prosper with them in Richmondshire. J. Philip.

They were found around 1780 by William Hawksworth and immediately considered to be a diabolical spell against the Phillip family and to be 'possessed of secret powers'. The antiquarian and *Somerset Herald* reporter, John Charles Brooke was asked to investigate

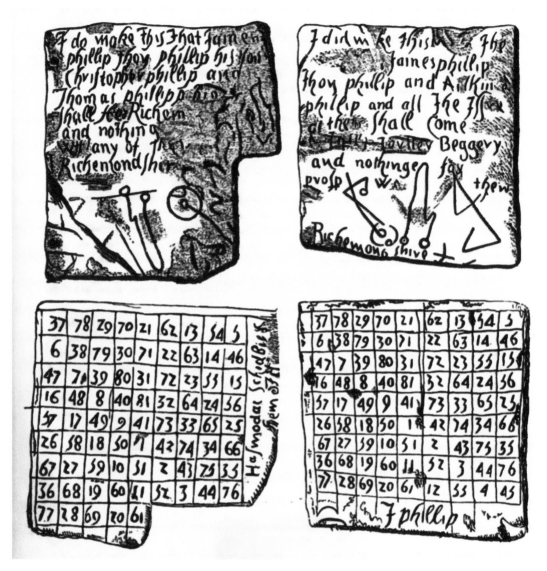

A sketch of tablets.

the names. He found in 1575 a James Philips from Brignall had five sons, John, Richard, Henry, Christopher and Thomas, who had all either died or their children had died without issue. He stated 'their estate, which seems to have been considerable in Brignall, is now the property of Sir Robert Eden.'

The curse does not seem to have been limited to the Philips family as only a few years later in 1794, while attending the Haymarket Theatre in Pall Mall, John Charles Brooke would be crushed to death in extraordinary circumstances. George III was expected and at the side door of the theatre a crowd of well-wishers were eager to see the king. Apparently a man at the front tripped and fell down the stairs, those behind kept pushing forwards,

causing a large group of some seventy people to be crushed. Fifteen people died on the spot with many more injured. One commentator said, 'Mr Brooke had died standing, as he was found as if asleep, and with colour still in his cheeks.'

Plague and Famine

The 1600s were a time of turmoil and upheaval for the whole country as well as Richmondshire. In 1622 and 1623 the northern uplands were struck with a major famine and though the country had been wracked by famine before, this period was of particular note. Following a record poor harvest in 1622, the following year resulted in high wheat prices and low sheep prices, which led to famine in the area. The worst effects of this were felt in north-west of the country, where Cumberland, Westmoreland and Dumfriesshire suffered particularly, evidenced by a significant rise in burials at this time, estimated to be around 20 per cent of the population. Even in parts of the lowland east of England the situation was desperate and a Lincolnshire landlord reported how one of his neighbours had been so hungry he stole a sheep, 'tore a leg out, and did eat it raw'. 'Dog's flesh', he wrote, was 'a dainty dish and found upon search in many houses'. In parts of Cumberland and Westmorland there were reports of the poor men, women and children starving to death in the streets.

There were further occasions of famine; for example in 1671 it was noted 'if great quantity of rye and other grain had not come in at Newcastle and Stockton, undoubtedly we would have had a great famine in Westmorland and Cumberland, Bishopric, Northumberland, and the North Riding of Yorkshire'. However, the famine of 1623 can be regarded as the last great famine.

The plague had also visited the area, but the 1597–98 occurrence is the best recorded, though it has been more recently suggested that the epidemic was not spread by rodents as is usually thought. Duncan and Scott are convinced the disease was not bubonic plague, carried by the fleas that lived on rats, but another highly infectious deadly virus called haemorrhagic plague. Records show the disease spread to Penrith from a man travelling from Richmond called Andrew Hogson, who was lodging in King Street. The plague is thought to have entered the region via Newcastle upon Tyne, which was, of course, was a very busy port at the time. The plague was first spotted in Newcastle early in 1597, having come in from Europe. Newcastle was ravaged by it and the disease slowly spread down to Durham, Darlington and Richmond before being spread further afield.

The region had been devastated previously by plague, probably since 1349, and the cemetery at Easby Church includes a plague stone. There is also a socketed base for a cross situated on the brow of a hill on the road between Richmond and Ravensworth. This is known as the plague stone and may have served as a memorial for plague victims, as well as for the exchange of money for food.

7. Villages of Swaledale

Catterick

The more modern village of Catterick lies to the south-east of Richmond, around a mile from the southern bank of the River Swale, but the older Roman town of Cataractonium is sited closer to the river and partially under the modern racecourse. The Roman road of Dere Street, later the Great North Road or most recent designation the A1, passed through or just past the settlement. The recent motorway upgrade near Catterick further revealed part of the Roman settlement and resulted in the discovery of more than 177,000 artefacts dating back to AD 60. Up until AD 60 this was the limit of the Roman expansion. From their main bases of Chester and York they chose to collaborate and trade with the local tribes until rebellion forced them to move north in AD 69.

After the Romans left, the city must have continued in use as there is reference to a battle taking place close to the town in AD 600, and it was finally destroyed by the Danes around Ad 766. The Battle of Catraeth was an important battle during the Anglo-Saxon invasion of the island in the late sixth and early seventh centuries. The Germanic Angles from southern Denmark and the native Celtic people fought to stop their lands being taken over by the invaders. The Celtic kings from Wales, Cumbria, Scotland and northern England banded together to rid themselves of the settlers. An epic poem tells of a bloody battle where many Angles were slain but in the end the result was a disaster for the Britons and led to the establishment of the Angle kingdom of Northumbria, encompassing all the land north of the River Humber to the Firth of Forth.

It is possible there was a motte-and-bailey castle next to the church in Catterick but the evidence is scant; however, further along the river to the south-east is an area called Castle Hills. This motte-and-bailey castle is thought to be a short-lived adulterine castle, erected during the civil war between Stephen and Matilda, which is known as The Anarchy. In all likelihood it was built by the Earl of Richmond, Alan the Black, during the conflict, and dismantled by order of Henry II. It has also been muted that the motte could have been modified from a natural hillock or a prehistoric burial mound.

Catterick's importance is raised due to its position at a major river crossing on the main road north on the eastern side of the country, and its role in history should not be underestimated. The village lends its name to the site of largest population in the area and when referring to Catterick, quite often it is Catterick Garrison that is brought to mind. Though the garrison is a huge modern conurbation, it is the historic town of Catterick that is steeped in history throughout the ages.

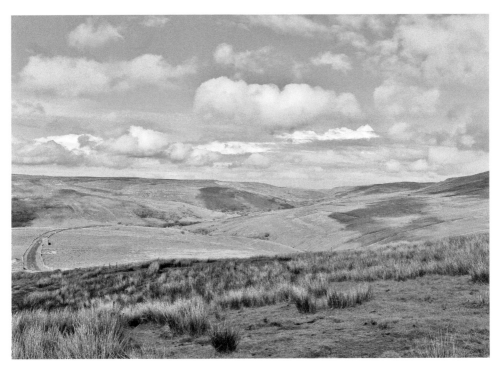

Looking into Swaledale from Cliff Gate Road.

Swaledale from Whipperdale Bank.

The hunting lodge above Grinton.

Swale Hall, Grinton

Tongue-twister alert! On the south bank of the River Swale, on Swale Hall Lane on the west side of Grinton, stands Swale Hall, the former residence of the Swale family.

There seems to be a great deal of mystery over the origins of the family and perhaps there was some creative genealogy on their part to appear to be a reputable family from the time of the Norman Conquest or even before this time. Having once been described as 'the ancientest gentleman in Yorkshire', they had dared to declare that Swaledale was actually named after them and not the river. Daniel Defoe wrote a brief passage about Swaledale: in his travelogue *A Tour Through the Whole Island of Great Britain*:

> The Swale is a noted river ... for giving name to the lands it runs through for some length, which are called Swale Dale, and to an ancient family of that name, one of whom had the vanity, as I have heard, to boast that his family was so ancient as not to receive that name from, but to give name to the river itself. One of the worthless successors of this line, who had brought himself to the dignity of what they call in London a 'Fleeter', used to write himself, in his abundant vanity, Sir Solomon Swale, of Swale Hall, in Swale Dale, in the County of Swale, in the North Riding of York.

The family arose to prominence with Solomon Swale, the son of Francis Swale of South Stainley in Yorkshire, who was admitted to Gray's Inn in 1630 as a lawyer and became a Member of Parliament for Aldborough in 1660. He was known as the first man in Parliament to propose the restoration of Charles II and for this service he was created a

baronet. Reputedly this was the very first Yorkshire baronetcy of the new reign. He was re-elected in 1661 for the Cavalier Parliament and was appointed High Sheriff of Yorkshire in 1670. This Solomon was succeeded in 1678 by his son, Henry, who was followed in 1683 by the Sir Solomon Swale, of whom Defoe was so critical.

DID YOU KNOW?
In 1547 the will of Jeffrey Charder of Reeth left 20s towards the building of Grinton Bridge, but the bridge needed to be repaired in 1565 and again in 1575.

Sir Solomon, the 3rd Baronet of Swale Hall, made great efforts to obtain recognition of the Swale manorial rights and began the story of ancient rights. Described as a 'man of great folly' and further criticised by the poet Alexander Pope, the clever mockery of his position by these prominent social commentators clearly reduced his standing in society. He was involved in a dispute with some local men about the true ownership of Swale Hall, and the complexity of the case meant his fortune was spent on legal fees. He eventually died in debt in Fleet Prison in 1733. He died unmarried, and was succeeded by his brother, Sir Sebastian Fabian Enrique Swale, on whose death – and with no male issue – the baronetcy became extinct. Swale Hall was sold by auction in 1786 and is now an unassuming farmhouse with an interesting past.

Blackburn Hall, Grinton.

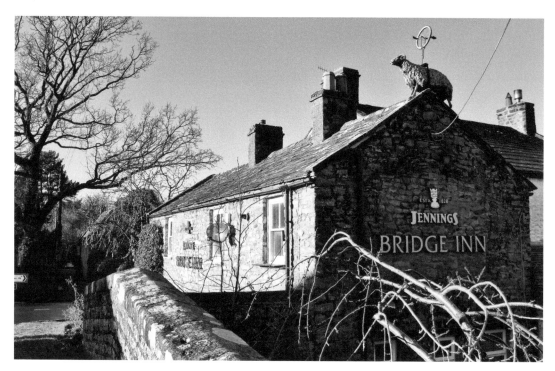

Bridge Inn, Grinton.

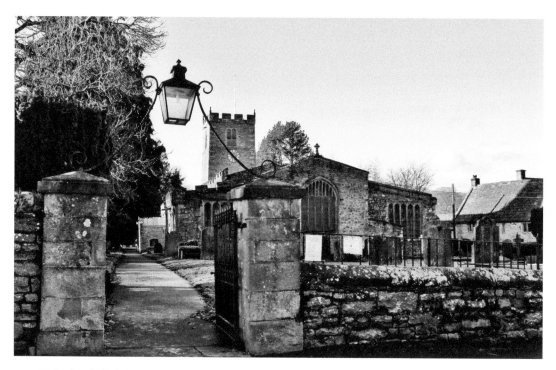

St Andrew's, Grinton.

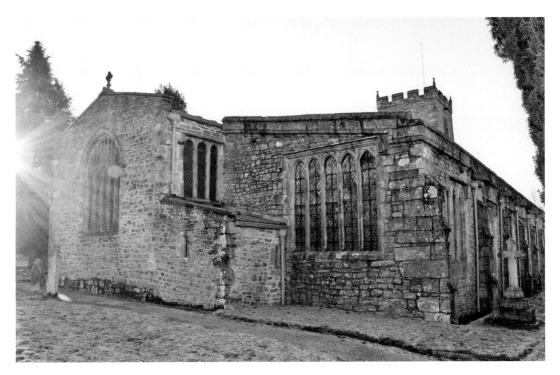

St Andrew's, Grinton.

Grinton Bridge over the Swale.

Dormouse Inn, Marske

According to the 1823 *Gazetteer*, a Jane Busby was the victualler of the Dormouse Inn at Marske, but apparently on Bonfire Night in 1900 there was a riot at the Dormouse and damage was done to the landowner's gates, fences and property. The inn lost its licence and the former public house is now Dormouse Cottage.

Swaledale Deer

Swaledale was once renowned for a good stock of deer, mainly due to the protection of the Wharton family, and are recorded in considerable numbers northward from Muker as late as 1725. However, as the mining became more industrialised and the land was filled with smelting mills, their old refuges in gills and woods were gradually vanishing. The stags died from a lack of winter food, while the remainder were easy prey for the poachers. There was also an increase in grouse shooting as a noble pastime and the land was taken over for this sport.

DID YOU KNOW?
Originally villages were generally laid out around a green as a method of protecting the livestock.

Muker Literary Institute.

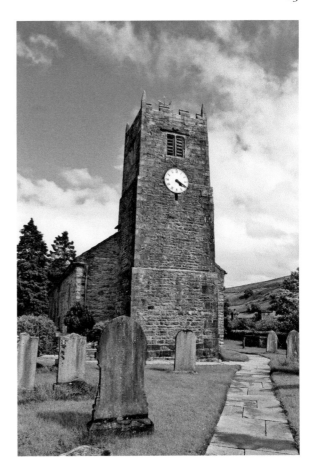

Muker Church.

Free School, Muker

Muker Free School was an old building that was maintained by subscription and endowed with 2 acres of land from the bequest of Anthony Metcalfe in 1678, and a further 16 acres were given by an unknown donor. This was used for the upkeep of a master and up to eight poor children.

Literary Institute, Muker

A building of interest in Muker is the Literary Institute, which was built in 1867 at a cost of £260. The money was raised by public subscription and included a William Tarn, who contributed a colossal £100. During the Victorian era many institutes or reading rooms were built to give working-class people access to some form of education. It was not until 1870 that state education was compulsory and poor people could not afford to educate their children unless a scholarship was gained. The institute gave the poor children and adults access to around 600 books. Grade II listed, this unusual building is built on a slope, with access via an entrance porch onto the first floor. Behind the porch is a Dutch-style gable with a spiked ball finial.

Keld Literary Institute.

St Mary's Church, Muker

St Mary's Church to the rear of the Literary Institute is an early example of a post-Reformation chapel, as it was built in 1580 but amended in the eighteenth century, and then much altered by the Victorians in the nineteenth century. The church is situated in a stunning location where it overlooks this beautiful village and the surrounding countryside.

As with most of the rural villages of Swaledale the population has decreased over the centuries since its industrial peak, and in an 1823 *Gazetteer* there were 1,425 people accounted for, but the 2011 census has this figure at only 249.

Crackpot Cavern and the Curious Pillar of Solid Stone

Throughout Swaledale there are extensive systems of caves, many of which are natural, due to the dissolvable limestone rock of the region, and these natural caves were added to by the mining operations carried out in this region. Crackpot Cavern is mentioned hundreds of years ago, being famous for its aptly named 'Column Chamber', which includes a floor to ceiling stone pillar of connecting stalactite and stalagmite.

Clearly a favourite with those who enjoy the exploration of deep dark holes in the earth, the *North Pennine Club Journal* in 1959 described an experience in Crackpot thus:

> Further progress was temporarily halted by a large block precariously perched in the
> roof. The sound of water was by this time much stronger, so, on the next visit the block

was stempled (crossbars to support) and made safe. By dint of much excavation, the Intestines were passed and a wide bedding plane about three feet high entered. This spaciousness was short lived, the passage rapidly ending in an extremely tight fissure four feet high and nine inches wide. Many a happy hour was spent here before the easy way was discovered, pushing and pulling the more corpulent members of the party through this fat man's agony. One on occasion, one gent was involved for nearly three quarters of an hour and eventually emerged badly scraped and without his nether garments.

Crackpot Hall

To the north of Muker on the slopes above the River Swale is the wonderfully named Crackpot Hall, although the name 'Crackpot' may just be Viking for 'a deep hole or chasm that is a haunt of crows'. Though the history of the place is hard to ascertain, it is understood to have originally been a sixteenth-century hunting lodge for Baron Wharton when the dale abounded with deer. Over the years the building has been adapted and changed, with the current ruin of a farmhouse dating from the mid-eighteenth century. The building is also said to have been used as mine offices associated with the lead mining industry. There are a number of outbuildings most likely used for wintering animals when it was a farm or used for storing equipment in the days of mining. The building was eventually abandoned in the 1950s due to subsidence and fell into severe decay but was saved by the Gunnerside estate with the aid of grants from the Millennium Commission and European Union through the Yorkshire Dales Millennium Trust.

As with every ruinous isolated building there are stories of hauntings and strange events, but one of the most unusual is the story of the 'wild child' found roaming the house and moors of Crackpot Hall. The story dates from the 1930s and has featured in stories as well as a Radio 3 programme. One observer believes the young girl was living alone at the house and the 'wild' child reference has been interpreted as a feral child. The girl, Alice, may have been the sister of a Stanley Harker, a Swaledale sheep breeder who had two brothers and three sisters including an Alice. He was born at Crackpot Hall in 1923, and would make his sister Alice around the right age.

'Black Boys', Gunnerside

The 'Black Boys' of Swaledale appeared in various newspapers in 1771 and appear to be a gang of local men who carried out an organised campaign of destruction against the absentee landowner Mr Thomas Smith (of Gray's Inn, London). It is suggested these men were agents of a Lord Pomfret, who inherited Swaledale mineral rights through his marriage to a Wharton heiress and was in dispute with Thomas Smith.

The corn mill at Gunnerside had its water race damaged and as soon as it was repaired 'the Black Boys immediately assembled, and destroyed it with their usual Brutality.' Apparently in the same year they also destroyed the water race at his smelting mill at Raygill and also 'threw down several of his hayricks'.

Mr Thomas Smith took them to court and in July 1771 the perpetrators were ordered to pay him 12 guineas as well as his costs.

Crackpot Hall. (Reproduced by kind permission of Marc Lowther)

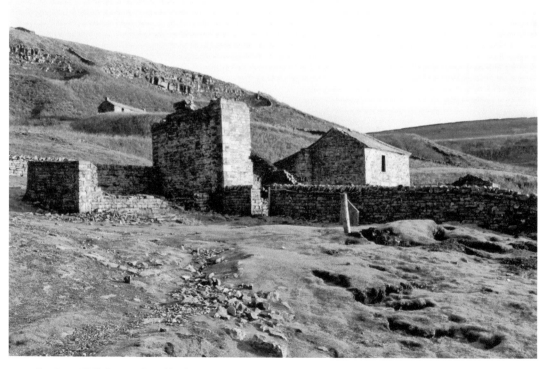

Crackpot Hall. (Reproduced by kind permission of Marc Lowther)

Crackpot Hall. (Reproduced by kind permission of Marc Lowther)

Gunnerside Literary Institute.

Gunnerside.

Reeth

Reeth is sited above the main valley at the confluence of the River Swale and Arkle Beck. This location suggests an early settlement as it is similar to other Iron Age layouts along important communication routes. The village is formed around a large village green, which has been a marketplace for years and is now separated by the main road. Though it is known the Romans exploited the mineral deposits of the area, there is little evidence for their settlement, and it could be the local populous was simply controlled from the forts at Catterick or that local leaders collaborated with the Romans.

Reeth translates in old English as 'rough place', and its location may have been the eastern boundary of an English kingdom in the seventh century. The ridge and furrow remains of medieval agriculture still survive in the area and the pattern of field boundaries is evidence of settlement during this time. The surrounding moorland would have been a source of peat, timber and game.

Philip Lord Wharton was an important figure in the economic development of Swaledale and the coal and lead mines during the seventeenth century, as well as obtaining a market charter for Reeth in 1695. The improvement of roads with the turnpike system

and the new bridge at Reeth in 1773 enabled the further development of the lead industry. The decline in the lead industry at the end of the nineteenth century left agriculture as the main economy of the area, only augmented by an increase in tourism.

DID YOU KNOW?
George Robinson, who erected the stone water supplies in Reeth, once lived in what is now the Burgoyne Hotel.

The decline of industry is clearly demonstrated by the population figures. In 1821 Reeth is recorded as the home of 1,460 soul but in 2001 this population was down to 724.

War Memorial, Reeth
One of the names on the Reeth war memorial is Corporal Thomas Hutchinson, who was from County Durham but served with the 4th Battalion, Yorkshire Regiment. He was killed on 9 November 1918, only two days before the ceasefire and was buried at Poznan Old Garrison Cemetery.

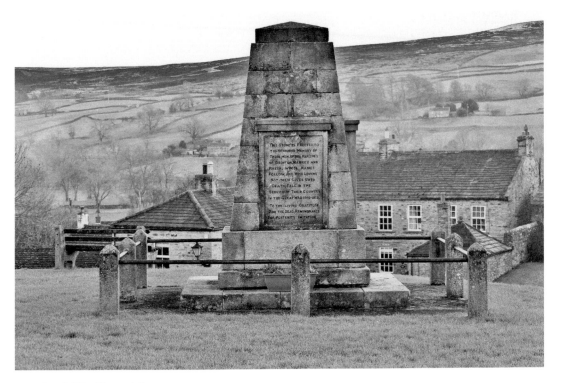

Reeth War Memorial.

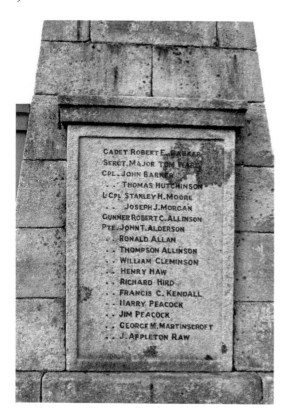

CADET ROBERT E. BARKER
SERGT. MAJOR TOM PEARS
CPL. JOHN BARKER
THOMAS HUTCHINSON
L-CPL STANLEY H. MOORE
JOSEPH J. MORGAN
GUNNER ROBERT C. ALLINSON
PTE. JOHN T. ALDERSON
RONALD ALLAN
THOMPSON ALLINSON
WILLIAM CLEMINSON
HENRY HAW
RICHARD HIRD
FRANCIS C. KENDALL
HARRY PEACOCK
JIM PEACOCK
GEORGE M. MARTINSCROFT
J. APPLETON RAW

Left: Remembered names of the First World War.

Below: Burgoyne Hotel, Reeth.

Right: One of two Reeth water supply fountains.

Below: George Robinson 1868 'by his munificence'.

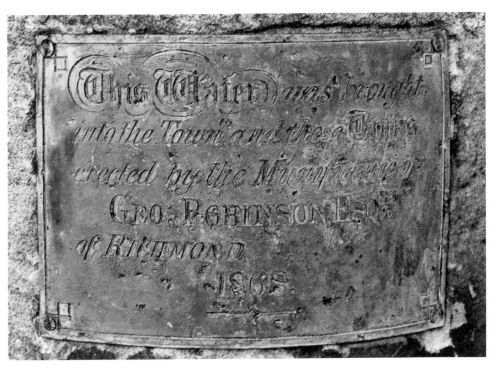

Swaledale Museum, Reeth

Swaledale Museum is in the village of Reeth and specialises in collecting objects and archives associated with Swaledale. The main focus of the museum is on lead mining, as well as the culture, people and artefacts involved in this industry. There is also a collection of rocks and fossils found in the area that tell of the creation of the dale from a geological point of view. It is well worth a visit as you explore the area.

Healaugh

There are written records referring to a hunting lodge or fortress associated to John of Gaunt, Duke of Lancaster (a significant character from history), being located in the general area of Healaugh. This was supposedly called Hall Garth and indeed there is still a field nearby called Hallgarth worthy of further investigation. Indeed, a recent archaeological investigation revealed an abandoned village north of the present village around the Daggerstones farm. There is a series of field systems associated with the late prehistoric/Romano-British farmsteads, as well as tracks and building platforms.

To the south of Healaugh is the remains of a fort called Maiden Castle. At only 100 yards square, it is suspected to be Roman in origin. The earthworks being Roman are further evidenced by finds of brass ornaments, inlaid with silver, and a Roman coin. Though these types of settlement are similar to Iron Age occupation throughout the dale, the finds may be simply associated with the locals trading with the Roman occupiers.

Keld

Keld is a small hamlet just off the B6270 Kirkby Stephen road and situated next to the Swale. The area is surrounded by the Norse field pattern and the hamlet itself is set around a square green. The buildings of particular interest are the Keld Literary Institute built in 1861, now the Heritage Centre and Keld United Reform Church. Keld Chapel is actually mentioned by Leland in 1540 but is known to have been a ruin in 1706. It was rebuilt as an Independent Chapel in 1789, and further modifications were made over the next eighty years.

Keld is also surrounded by many beautiful natural features including Kisden Force, Catrake Force and Wain Wath Force, waterfalls along the River Swale. Many of the walks around Keld and Muker are thought to be the finest and most picturesque in the whole of Swaledale.

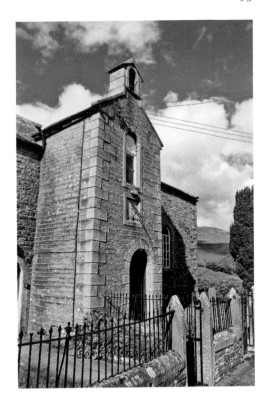

United Reform Church, Keld.

Keld Literary Institute.

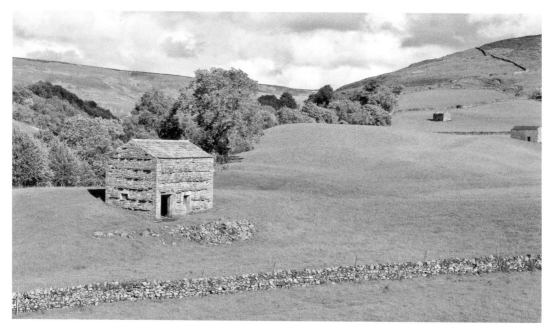

A picture-postcard view of a Yorkshire Dales scene at Keld.

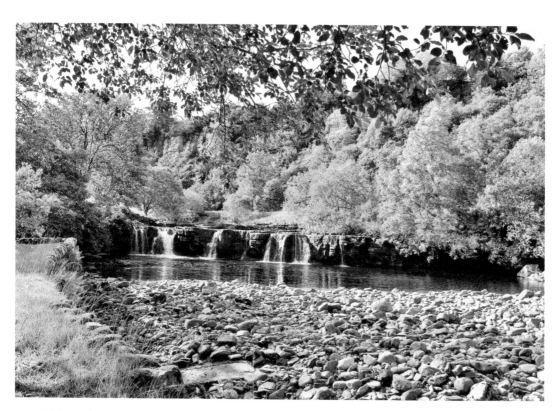

Wain Wath Force.

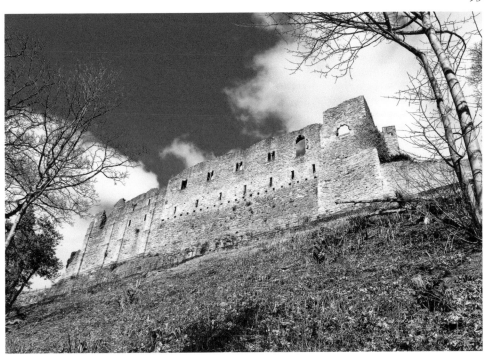

Above: Richmond Castle from the Swale.

Right: Castle Walk, Richmond.

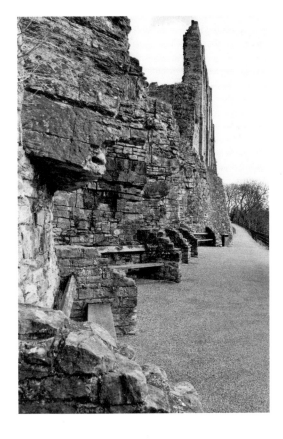

Selected Bibliography

History, Directory & Gazetteer of the County of York (1823)

Jane Hatcher, *The History of Richmond, North Yorkshire* (2004)

K. J. Kesselring, *The Northern Rebellion of 1569* (2010)

K. Laybourn, *Monastic Gilling* (1979)

Liam Waller, *Walks of Richmond* (self-published, 2018)

T. D. Whitaker, *The History of Richmondshire* (1823)

The Rivers of Great Britain (1892)

William Woolnoth & E. W. Brayley, *Ancient Castles of England & Wales* (1825)

www.british-history.ac.uk

www.darlingtonandstocktontimes.co.uk

www.english-heritage.org.uk

www.historicengland.org.uk

www.thenorthernecho.co.uk

www.willswales1.wordpress.com

www.workhouses.org.uk

Acknowledgements

Thank you to the people of Richmond and Swaledale who have been very welcoming during my visits. Further thanks to my wife and exploration partner, Gillian, the publishing team at Amberley and Marc Lowther for the use of some of his photographs.